ADJUSTING FOUNDATIONS

JOHN HEJDUK

THE MONACELLI PRESS

First published in the United States of America in 1995 by
The Monacelli Press, Inc.
10 East 92nd Street, New York, New York 10128,
in collaboration with The Cooper Union for the Advancement of Science and Art.

Library of Congress Card Catalog Number: 95-75840
ISBN 1-885254-06-7

Designed by Kim Shkapich
Printed and bound in Italy

TING

DATIONS

DUBLIN
DUBLIN TECHNOLÓGICA
BAILE ÁTHA CLIATH
TECHNOLOGICAL
UNIVERSITY DUBLIN

EDITED BY KIM SHKAPICH

Dedicated to The Cooper Union for The Advancement of Science and Art
and to my wife, Gloria Fiorentino,
graduate of the School of Art—two forces that deeply moved my spiritual life.

68	70	72	74	75	77	78	80	82	84	86	87
FIVE PIECES IN FOLK STYLE: ROBERT SCHUMANN	ONE GALLERY AND THREE MUSEUMS	+ − x ÷	FIXED FLIGHT	CHAPEL AND TOMBS	NIGHT HOUSE	HOUSE FOR THE KEEPER OF THE ARCHIVES ON PERSEPHONE	HOUSE OF THE DEAD	THEATER OF THE DEAD	THE STILL LIFE PAINTER'S COMPLEX	CHAPEL	WAREHOUSE

89	90	94	98	102	106	112	113	114
CHURCH COURT GARDEN	GARDEN COURTS AND CHAPEL	STILL LIFE MUESUM/MUSEUM FOR STILL LIFE	TWO CHAPELS FOR THE DEAD: HEAVEN-HELL/DAY-NIGHT	ADJUSTING FOUNDATIONS	TWO CHAPELS FOR THE DEAD: NORTH WEST EAST SOUTH	THE SACRED AND THE PROFANE	NIGHT THOUGHTS FOR DAY DREAMS	CHURCH

115	116	117	118	122	128	129	130	131	133
CHAPEL	SANCTUARY	BAPTISTRY	CHURCH CHAPEL STAR STONE	RED CATHEDRAL. AND A CRECHE OF ANGELS FLEW FROM THE WALL	A PAINTERS HOUSE	LIBRARY FOR STILL LIFES	CATHEDRAL	CHURCH AND BAPTISTRY	TUNIS: CARTHAGE

200	201	202	203	204	210	215	220	221	223
TOMB OF THE SUN MOON AND STAR	MUNICIPAL BUILDING FOR BAKU	COMMUNITY CENTER	VLADIVOSTOK	HOUSE IN HARBIN	ICARUS ARISEN–PERSEPHONE'S DESCENT	SEVILLE STRUCTURE	PASSAGE	THE WOODEN MEDUSA	WEDNESDAY DECEMBER 7 4 AM

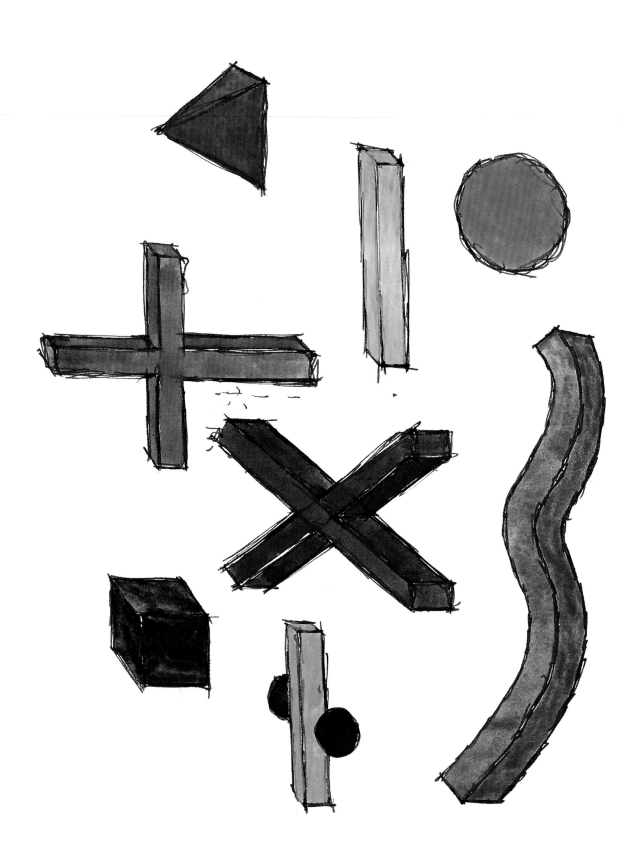

The problems of point-line-plane-volume, the facts of square-circle-triangle, the mysteries of central-peripheral-frontal-oblique-concavity-convexity, of right angle, of perpendicular, of perspective, the comprehension of sphere-cylinder-pyramid, the questions of structure -construction-organization, the question of scale of position, the interest n post-lintel, wall-slab, the extent of a limited field, of an unlimited field, the meaning of plan, of section, the meaning of spatial expansion–spatial contraction–spatial compression–spatial tension, the direction of regulating lines, of grids, the forces of implied extension, the relationships of figure to ground, of number to proportion, of measurement to scale, of symmetry to asymmetry, of diamond to diagonal, the hidden forces, the ideas of configuration, the static with the dynamic: all begin to take on the form of a vocabulary.

—*Three Projects*, 1969

The inhabitants arrive by boat on the canal. They disembark and move through a snakelike hedge maze. This maze is on a horizontal earth plain. The maze continues up, sloping on a 30° incline, and ends at the edge of a horizontal plateau in front of a high wall with a vertical maze painted on its surface. It is a plan of the maze. Puncturing this surface elevation is a series of different-sized square cutouts. Within the cutouts are solid-colored planes of blue, orange, brown, red, and black. These cutouts have windows placed within them. The square elevational planes can be raised entirely, as in a theater, revealing the whole room behind it.

The north wall is deep blue with black metal stars protruding through the surface. In front of this wall, wooden structures are placed that are the extensions of the maze wall rooms; also between the two vertical walls (painted maze wall and the blue wall) is a series of rooms that act as an internal vertical labyrinth. The star-studded blue wall faces a dark pine forest. Across the canal is an observation tower.

OBSERVATION TOWER CANAL MAZE ON FLAT SURFACE

M
A
Z
E

O
N

30°

I
N
C
L
I
N
E

H
O
U
S
E

P
I
N
E

W
O
O
D
S

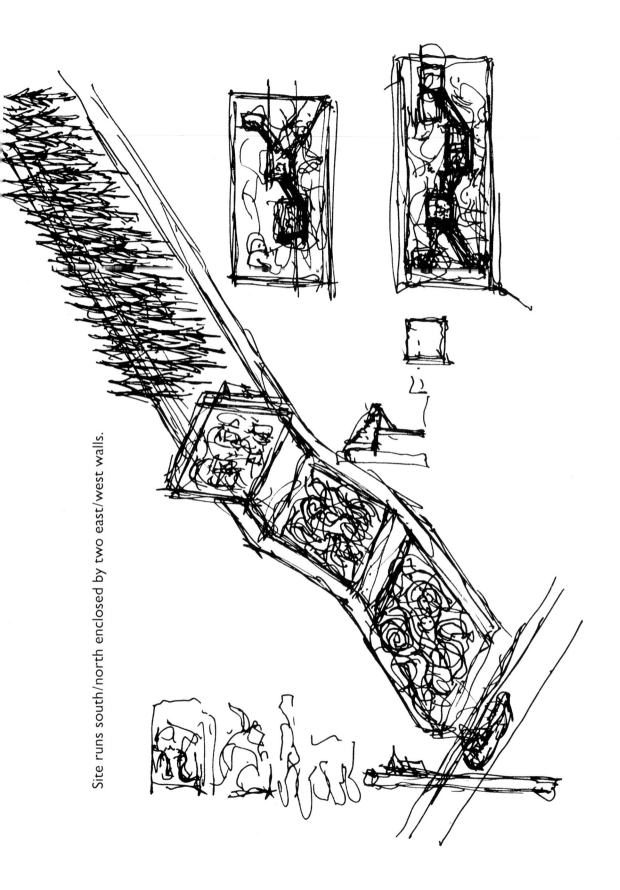

Site runs south/north enclosed by two east/west walls.

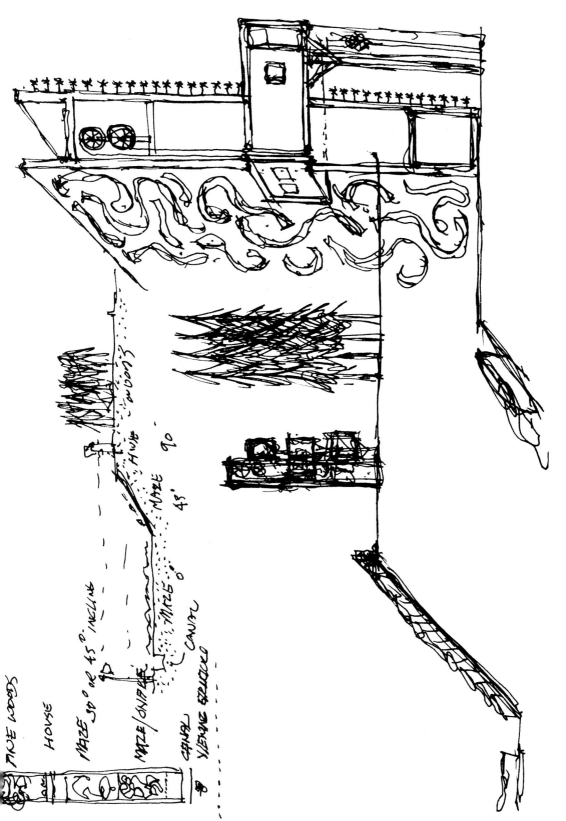

PINE WOODS

HOUSE

MAZE 30° or 45° INCLINE

MAZE/SNIPPE

CANAL

VIEWING STRUCTURE

HUGE WOODS

MAZE 45°

MAZE 0°

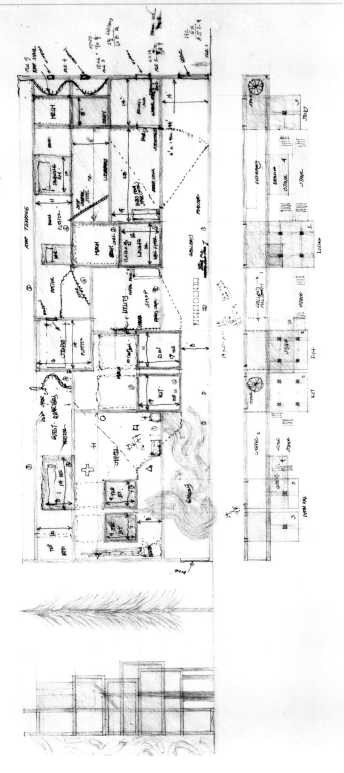

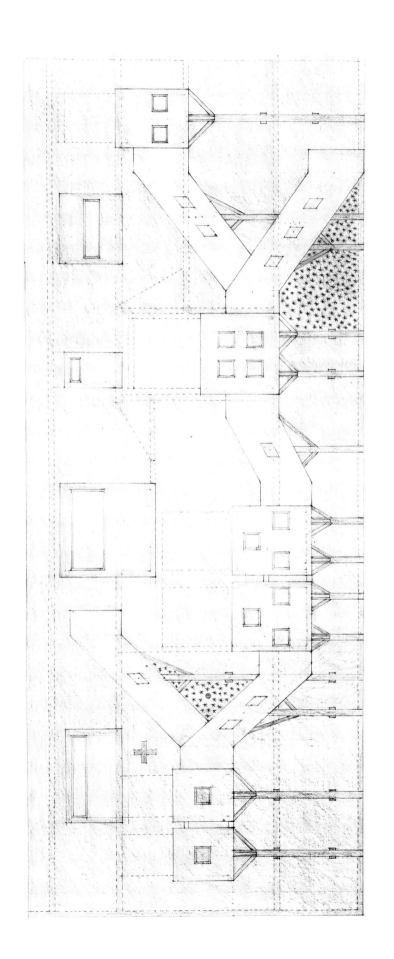

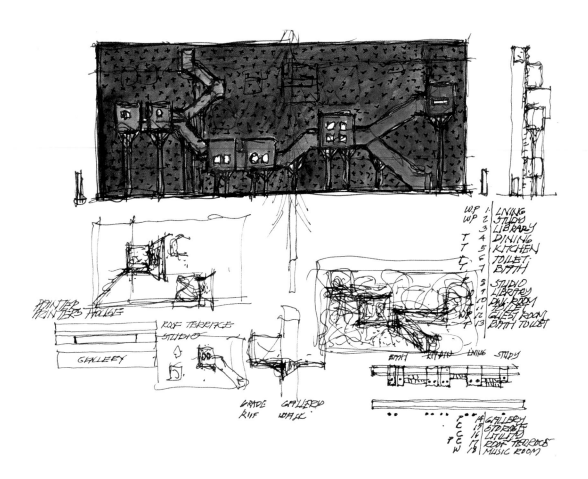

PAINTER
PRINTERS HOUSE

ROOF TERRACE
STUDIO

GALLERY

GRADE
ROOF

GALLERY
WALK

W.P	1	LIVING
W.P	2	STUDIO
	3	LIBRARY
T	4	DINING
T	5	KITCHEN
Cy	6	TOILET
	7	BATH
	8	STUDIO
	9	LIBRARY
	10	DRV. ROOM
	11	GUEST
WR	12	GUEST ROOM
T	13	BATH TOILET
	14	GALLERY
	15	STORAGE
	16	UTILITY
	17	ROOF TERRACE
W	18	MUSIC ROOM

BATH KITCHN DINING STUDY

R
E
D

L
I
V
I
N
G

R
O
O
M

Y
E
L
L
O
W

K
I
T
C
H
E
N

O
C
H
E
R

D
I
N
I
N
G

B
L
U
E

B
A
T
H

B
R
O
W
N

B
E
D
R
O
O
M

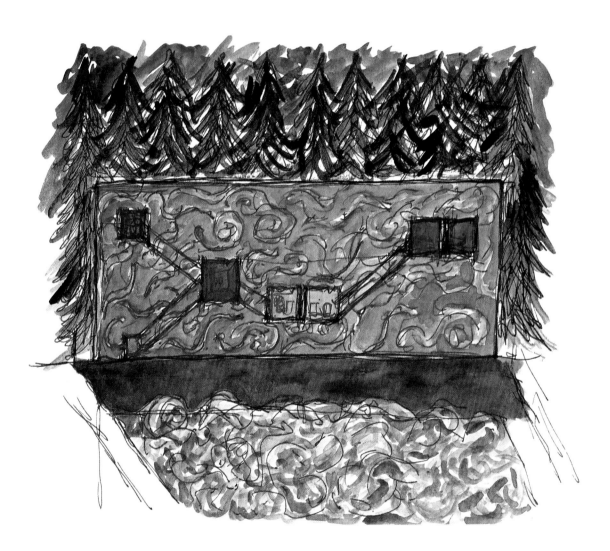

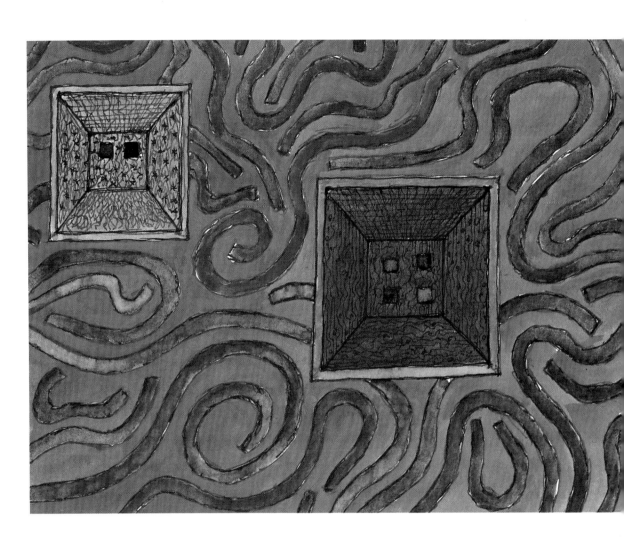

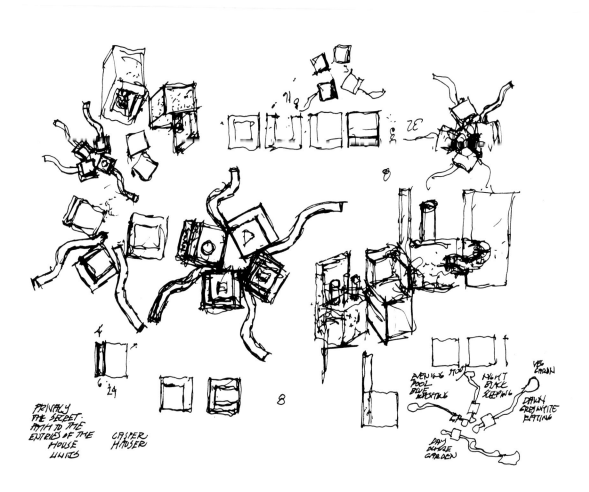

PRIVACY
THE SECRET
PATH TO THE
ENTRIES OF THE
HOUSE
UNITS

CASPER
HAUSER

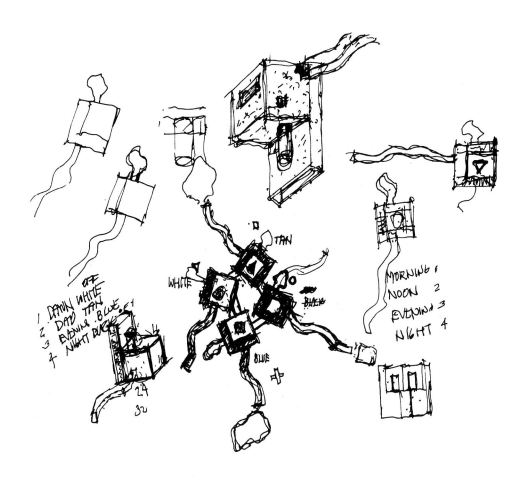

There is a moment in Werner Herzog's film about Casper Hauser when the director interposes a flickering shot of Angkor Wat—if it is Angkor Wat.

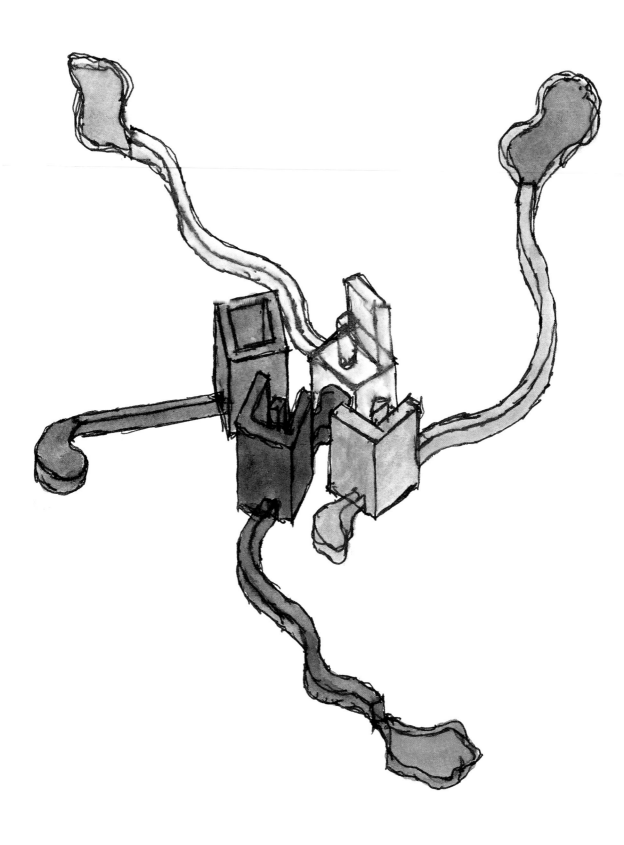

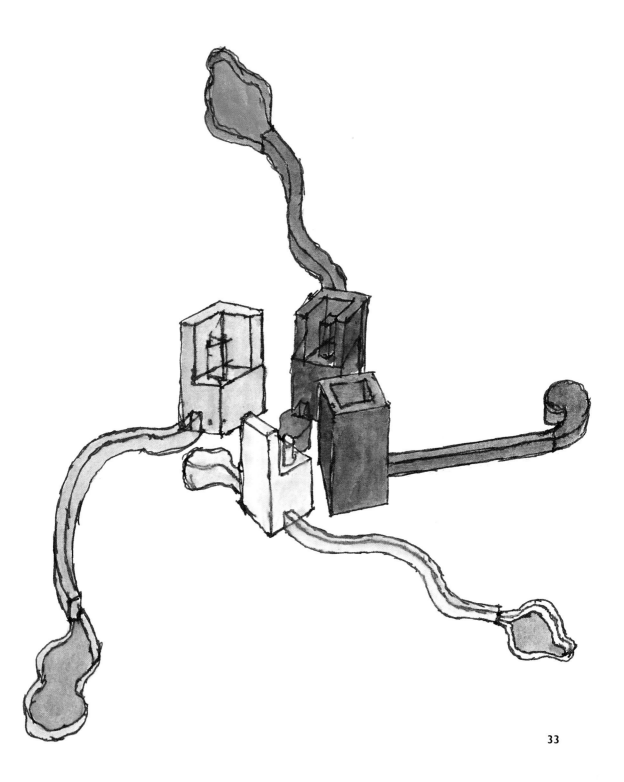

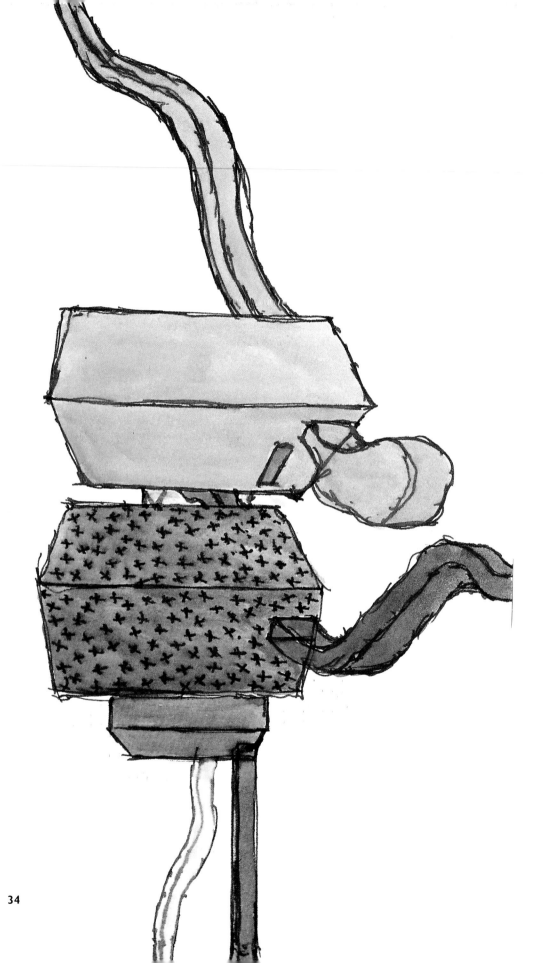

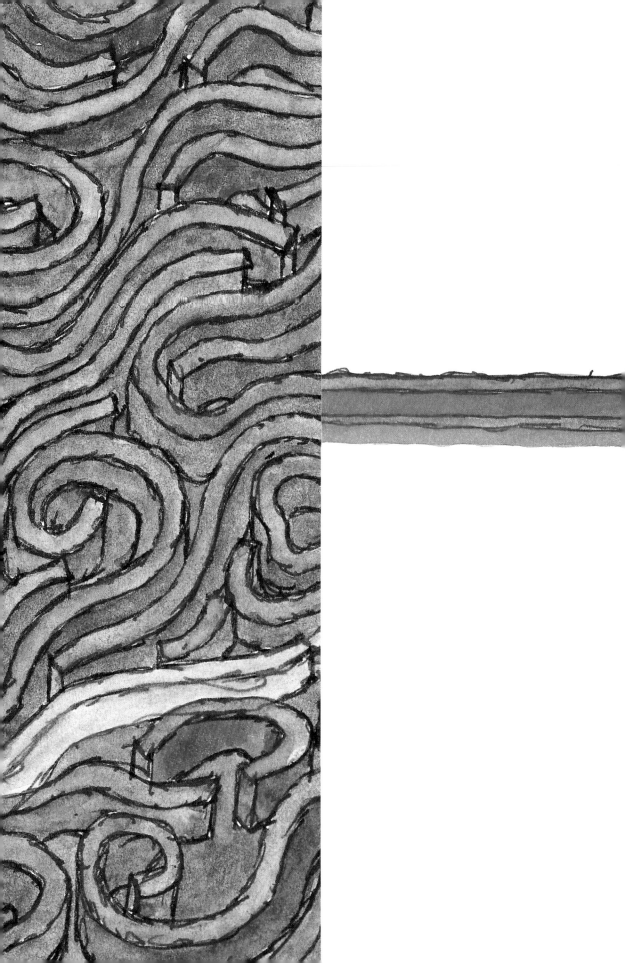

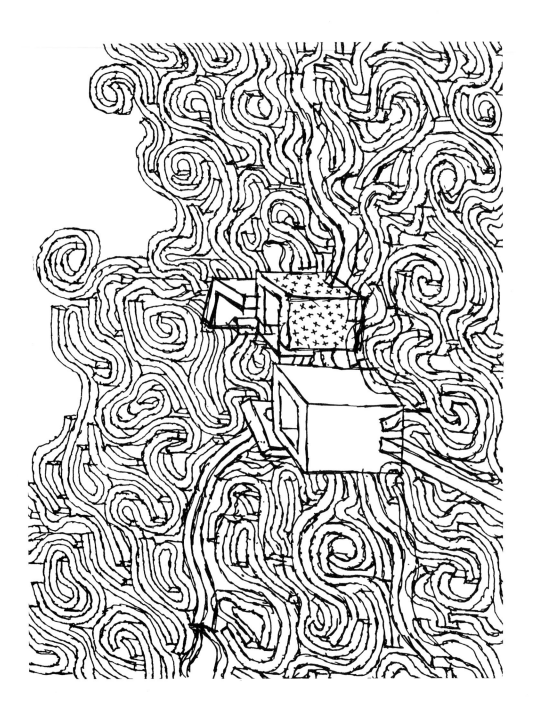

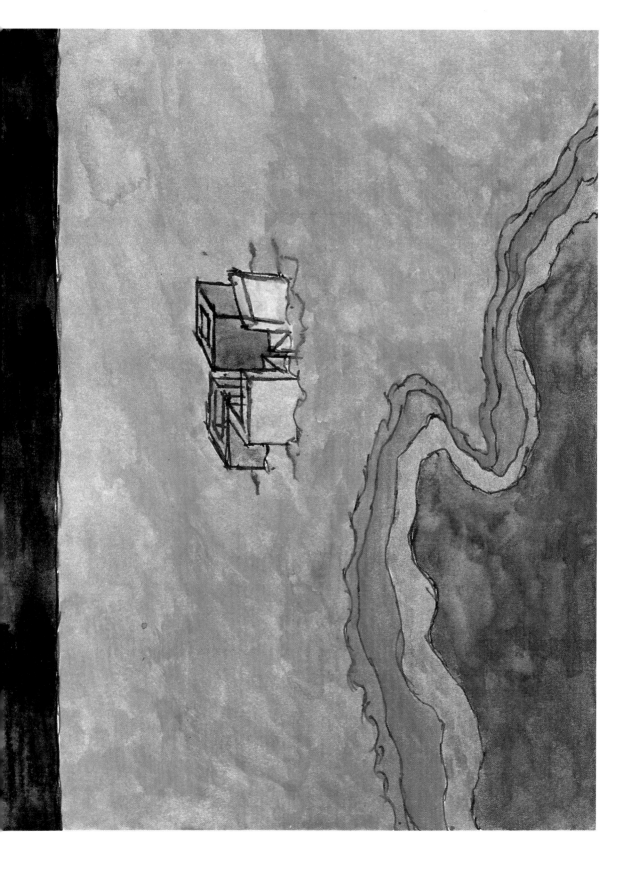

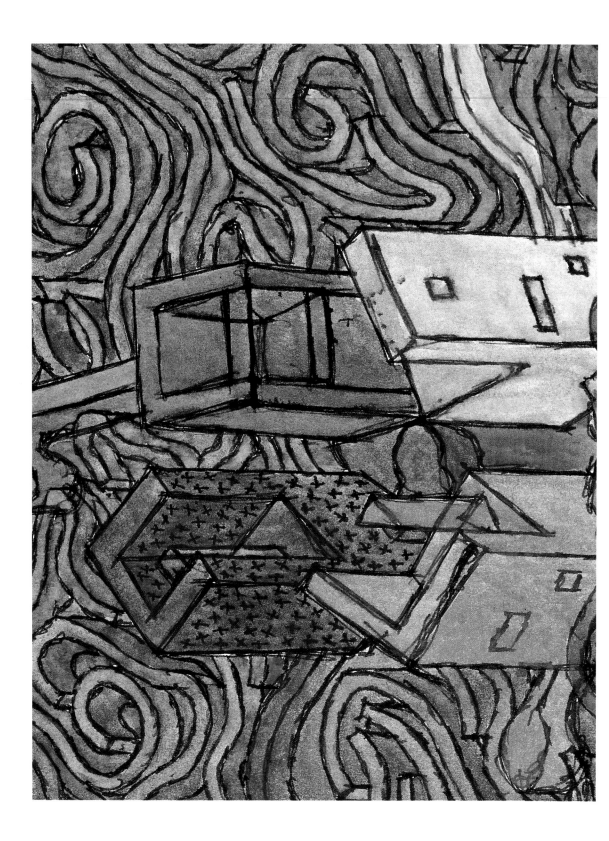

He was shown documents, writings, drawings, and paintings of mythical animals and yet simply could not be convinced of their existence. Late one evening he visited the Archaeological Museum in Athens. On his way there he rested on a bench under an orange tree. He was thirsty and reached up to take an orange. The orange had the weight of a steel ball. It was very hot and burned the palm of his hand. He let it slip from his hand; it fell to the ground with a thud. He brought the heel of his shoe down on the fallen fruit and smashed it into vermilion-white crystals. He looked up to a window in the museum and saw the head of a bull staring out at him. He never entered the museum, for at that moment he knew that there were no myths.

POSEIDON AND PERSEPHONE'S TOMBS

Persephone (from *phero* and *phonos,* "she who brings destruction"), also called Persephatta at Athens (from *ptersis* and *ephapto,* "she who fixes destruction") and Proserpina ("the fearful one") at Rome, was, it seems, a title of the Nymph when she sacrificed the sacred king.

Poseidon's feasts are . . . observed on the [eighth day] of the month, since eight, being the first cube of an even number, represents Poseidon's unshakeable power.

—Robert Graves, *The Greek Myths*

A
C
R
O
P
O
L
I
S

Your departures
and
your erasures
left
your vagueness

Snails live in
the crevices of
your shattered marble

Your heart pumps thoughts
incomparable

Exit implies entry's lament

PAINTER'S CITY HOUSE BY THE CANAL BORDERS PINE WOODS

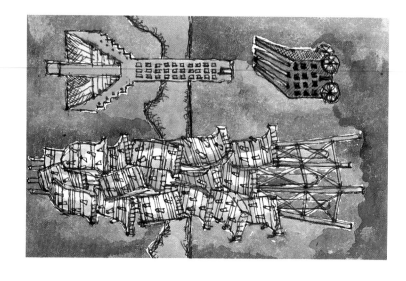

Painter's house : a still life.
From the outdoor seating the painter observes his house.

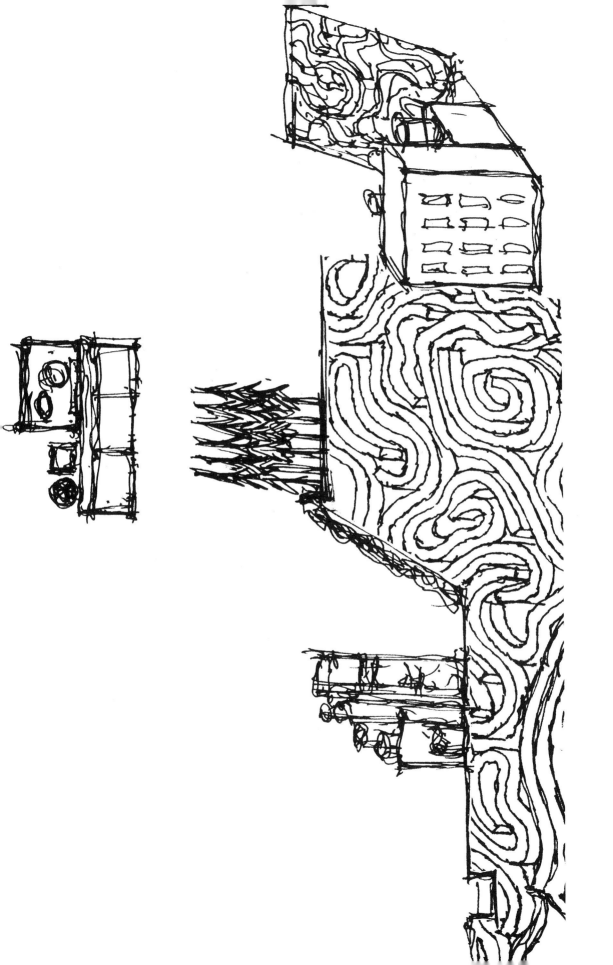

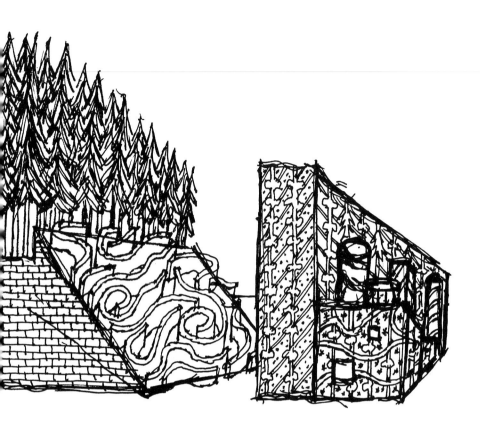

S T O N E R O O M
B R I C K R O O M
S T U C C O R O O M
S T E E L R O O M
W O O D R O O M
G L A S S R O O M

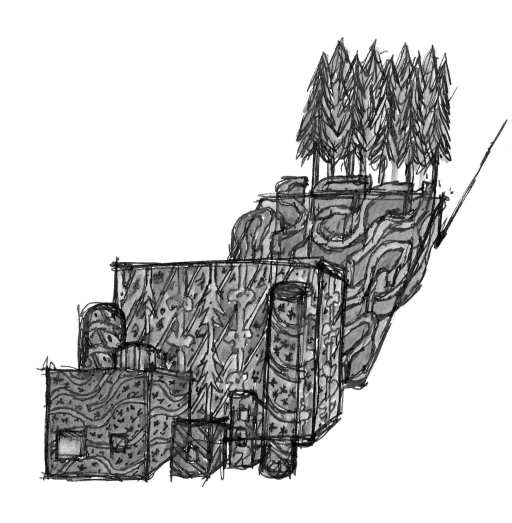

CEMETERY FOR THE ASHES OF THE STILL LIFE PAINTERS

Time heals, so it is said. Not all the time. Sometimes time disappears and, at one time, stops altogether. It is all right if we can remember stilled time, a paradox. For we cannot really remember still time; we can only remember the time before still time and, if we are fortunate, the time after still time. Nothing is more frightful than the moment before still time (remembered time in its deepest nothingness), and nothing more centering, more sacred, than the moment after still time.

We seldom look at the real meanings of certain pairings of words; if we did, they might still stop us.

In painting, the English term *still life* and the Italian term *natura morta* haunt. Not an innocent combining of two words: in English, "still life"; in Italian "dead nature."

The painter can set up a composition on a table of a so-called still life/natura morta—bowls, fruits, tablecloths, bottles, glasses—and paint it on a two-dimensional canvas as he sees it or re-imagines it; however within the arranged three-dimensional still life, certainly in the case of the fruit (apples, pears, grapes), there is a rotting taking place, and this in time destroys the original still life through organic decay (perhaps meaning nature dying). Painting can also capture, as Matisse has indicated, the "singular"—a singular moment in time. The sarcophagus of the still life is the opaque, "life-absorbing" flat canvas. In one move the painter has embalmed a still life into a natura morta. He is the contractor or the undertaker of nature.

The great painters have viewed/confronted still life/natura morta. They are the River Styx boatmen, taking stilled life to the underworld; that is, some of them do. Nothing is frivolous in stilling life. Time, some time, no matter how infinitesimal, is necessary for the crossover. The painter accompanies life to its stillness or fixes nature, consequently defying mortality. The painter is mortal; the painting immortal. The beautician and mortician work together, one hiding life, the other hiding death. The painter's still life is nature; God's still life is man.

In Braque's painting *Studio III* (1949), the bird of death flies through the wallpaper of a room. The bird is caught within the wallpaper's pattern on the wall. It is caught in the patterns of many layers of peeled wallpapers, oblivious to the death entanglement of the surfaces. In his *Studio II* (1949), the bird is observed by a man's head; we are not sure if it is the painter's head or even perhaps a cast head—we are not sure. The bird is agitated and can be seen as moving into and parallel to a window, about to be entwined in the wallpaper of the room. Another viewing of the painting could be that the former head of the painter, instead of being on the pewter platter of Salomé, is placed on the wood palette of the painter. In any case, the bird in the paintings desires entry into the room to be finally enmeshed, as a shark is enmeshed in an undersea net. The painter attempts to capture death, or at least a fleeting thought. Almost twenty years later, in the Braque painting *The Dead Bird* (1957), the black bird lies on its back—a natura morta, a stilled life.

If the painter could, by a single transformation, take a three-dimensional still life and paint it on a canvas into a natura morta, could it be possible for the architect to take the natura morta of a painting and, by a single transformation, build it into a still life?

The Cemetery for the Ashes of the Still Life Painters is an architect's thoughts upon the above conditions, and all the thoughts in this book are in one way or another related to the flight of the dark bird through the depths of flat surfaces, which, in the end, is a celebration.

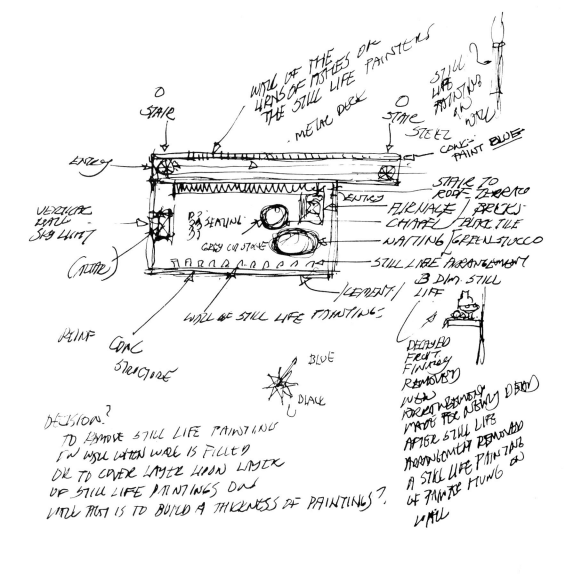

O STAIR

WALL OF THE URNS OF ASHES OF THE STILL LIFE PAINTERS

METAL DECK

O STAIR

STILL LIFE PAINTING ON WALL

STEEL

CONC. PAINT BLUE

ENTRY

STAIR TO ROOF TERRACE

VERTICAL WALL SKY LIGHT

(ALTAR)

ENTRY

B2 SEATING 33

GREY CUT STONE

FURNACE / BRICKS

CHAPEL / BLACK TILE

WAITING / GREEN STUCCO

STILL LIFE ARRANGEMENT

3 DIM. STILL LIFE

/ CEMENT / LIFE

WALL OF STILL LIFE PAINTINGS

REINF CONC STRUCTURE

BLUE

BLACK

DECAYED FRUIT FINISHES REMOVED WITH ARRANGEMENT MADE FOR NEWLY DEAD AFTER STILL LIFE ARRANGEMENT REMOVED A STILL LIFE PAINTING OF SAME HUNG ON WALL

DECISION?
TO REMOVE STILL LIFE PAINTING
ON WALL WHEN WALL IS FILLED
OR TO COVER LAYER UPON LAYER
OF STILL LIFE PAINTINGS ON
WALL THAT IS TO BUILD A THICKNESS OF PAINTINGS?

ENTRY

SEATING

STAIR LEADING TO ROOF TERRACE

FURNACE / CREMATORIUM FIRE

On the roof terrace is an oval waiting room with a green stucco finish and, for the family, a round chapel constructed of black tile.

Behind the church rises a blue slab, a narrow space containing two circular steel stairs, one at each end, connected by a gridded steel deck. One wall is a grid of slots where the urns of the ashes of the still life painters are placed, facing the landscape. The opposite wall of the blue slab, on the church side, is filled with protruding metal stars.

The crematorium furnace rises from the basement through the church and is exposed on the roof terrace.

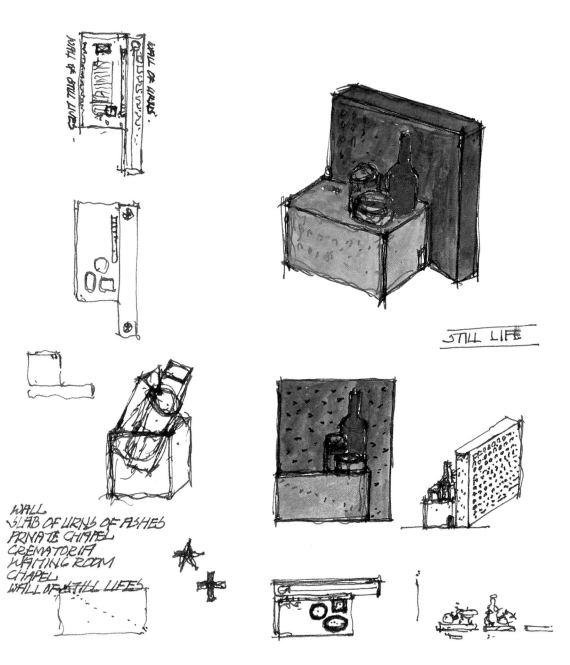

STILL LIFE

WALL
SLAB OF URNS OF ASHES
PRIVATE CHAPEL
CREMATORIA
WAITING ROOM
CHAPEL
WALL OF STILL LIFES

CEMETERY OF THE ASHES OF THE PAINTERS OF STILL LIFE

Inside the church is a wall for mounting still life paintings. It has small, cantilevered slabs for holding still life arrangements composed by the family of the still life painter.

After the organic elements (apples, pears, etc.) decay, the three-dimensional still life arrangement is removed and a still life painting by the painter is hung on the wall above the cantilevered slab. Eventually the wall will be completely covered with still life paintings. When it is full, the paintings of future still life painters will be mounted over existing still life painting, until the church's interior is filled volumetrically. This solid volume of paintings—solidified space—seals the church.

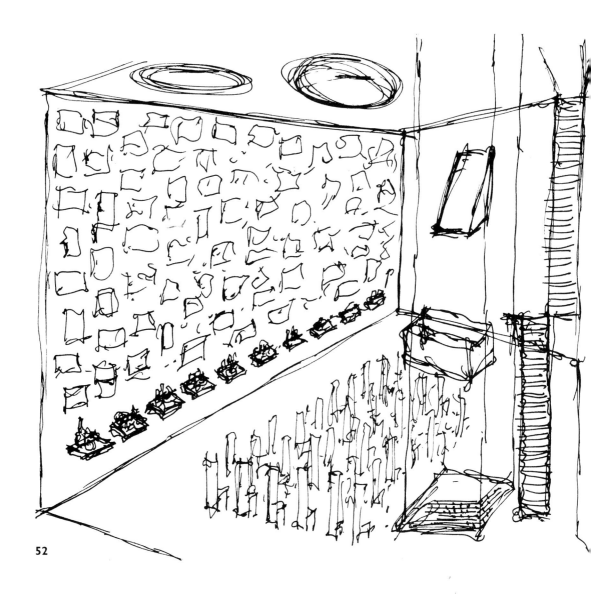

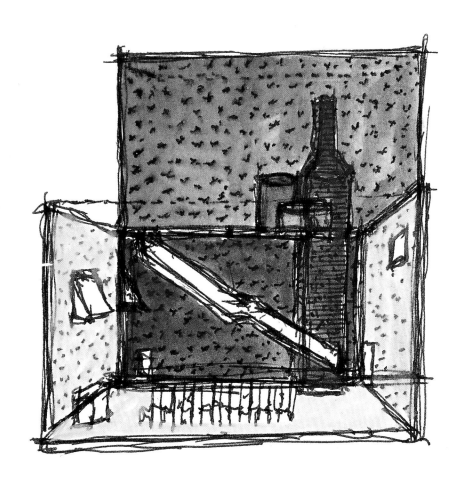

W S P C W C W
A L R R A H A
L A I E I A L
L B V M T P L
 S A A I E

WALL SLABS OF URNS OF ASHES PRIVATE CHAPEL CREMATORIUM WAITING ROOM CHAPEL WALL OF STILL LIFES

HISTORY. The practice of cremation on open fires was introduced to the Western world by the Greeks as early as 1000 B.C. They seem to have adopted cremation from some northern people as an imperative of war, to ensure the soldiers slain in alien territory a homeland funeral attended by family and fellow citizens. Corpses were incinerated on the battlefield; then the ashes were gathered up and sent to the homeland for ceremonial entombment. Although ground burial continued (even a symbolic sprinkling of earth over the body fulfilled requirements, as *Antigone* reveals), cremation became so closely associated with valor and manly virtue, patriotism, and military glory that it was regarded as the only fitting conclusion for an epic life....

The Romans, on the other hand, observed all the proprieties. They covered the pyre with leaves and fronted it with cypresses; after it was set ablaze, troops shouting war cries circled it and cast trophies taken from the slain Latins into the fire. They poured the blood of animals on the flames, and, when the fires were quenched, washed the bones in wine and placed them in urns.... By about A.D. 100, however, cremations in the Roman Empire were stopped, perhaps because of the spread of Christianity. Although cremation was not explicitly taboo among Christians, it was not encouraged by them because of pagan associations and because of the concern that it might interfere with the promised resurrection of the body and its reunion with the soul.

MODERN CREMATIONS. Open fires are not used; instead, the body is placed in a chamber where intense heat transforms it in an hour or two to a few pounds of white, powdery ash. That is disposed of in accordance with law and sentiment.

—*The New Encyclopaedia Britannica Micropaedia*

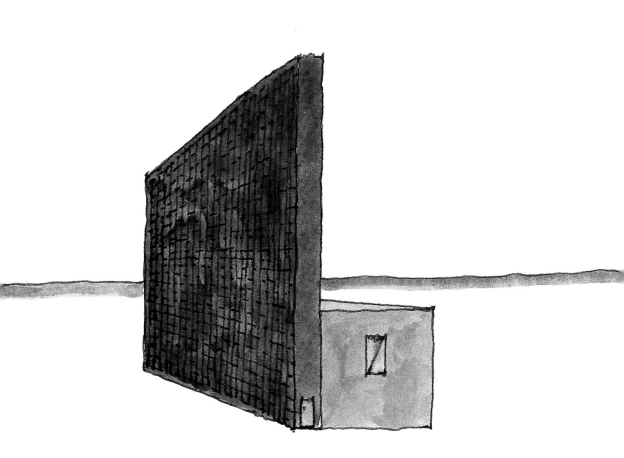

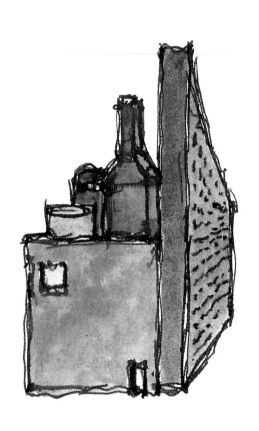

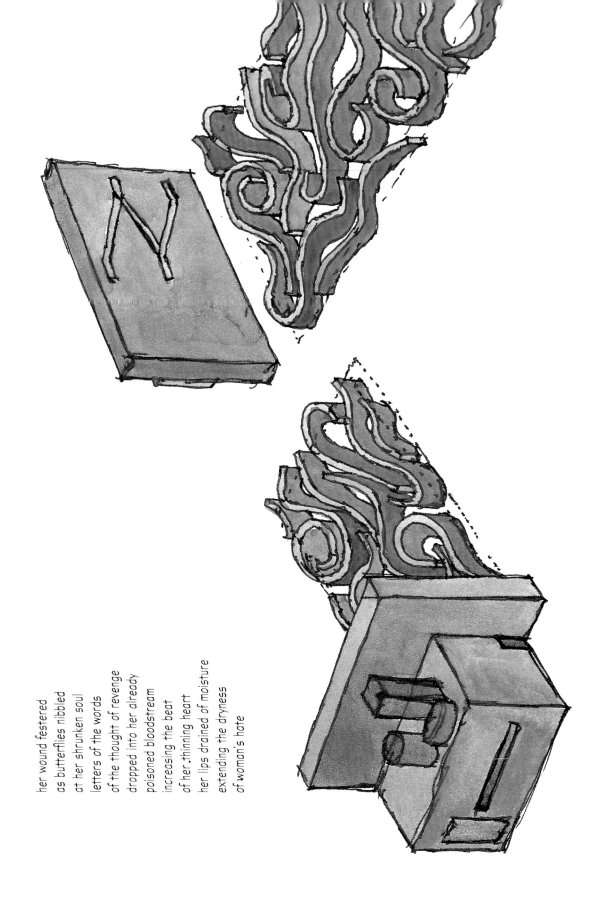

her wound festered
as butterflies nibbled
at her shrunken soul
letters of the words
of the thought of revenge
dropped into her already
poisoned bloodstream
increasing the beat
of her thinning heart
her lips drained of moisture
extending the dryness
of woman's hate

GARDEN

STAIRS LEAD TO STORAGE AREAS

SLAB: STORAGE FOR THE PAINTINGS

ROOF VOLUMES: ELEMENTS OF HOUSE

LARGE VOLUME: STUDIO

HOUSE/STUDIO OF THE STILL LIFE PAINTER

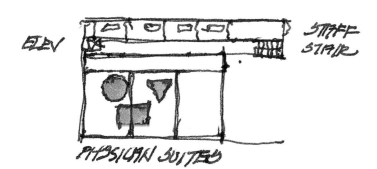

DELIVERY ROOM OPERATING ROOM MORGUE BIRTH LIFE DEATH WAITING ROOM WAITING ROOM WAITING ROOM ANNOUNCEMENT SOUND/SILENCE PRONOUNCEMENT BIRTH WEIGHT WEIGHT DEATH WEIGHT EYES FIRST OPEN EYES OPEN CLOSE EYES LAST CLOSED

He thought he heard
it enter the still life
although the shutters
were closed
He sat in the wood chair
and waited
for the return
He dreamed of the
cliffs of Le Havre
The rooms somehow
were always permeated
in greens and browns
Suddenly
a lone gull
silently flying appeared
wings interweaving
within the vertical stripes
of the wallpaper
His soul was released
inside
it became white

The hospital—opacity of reflectivity.
The thickness of thought, although thought is of no substance.

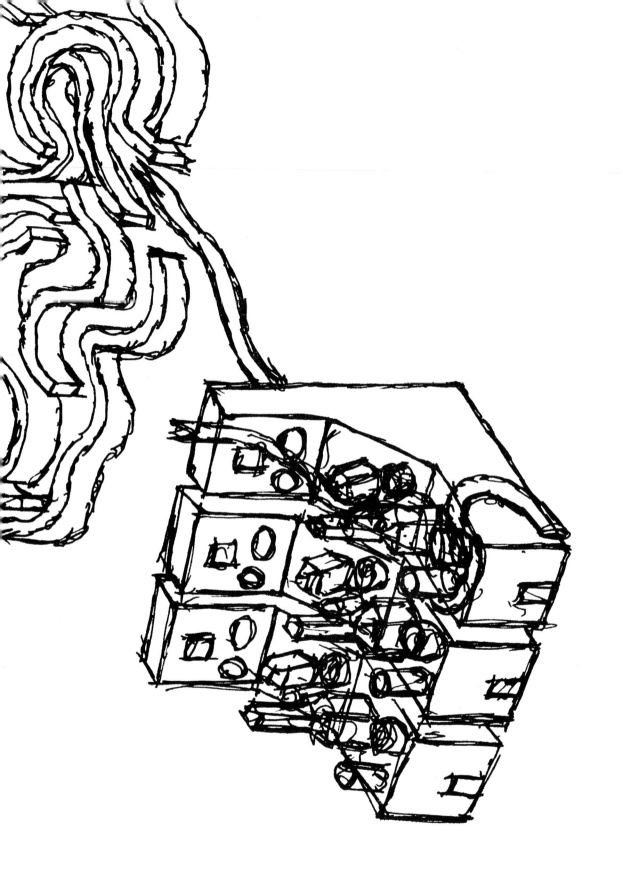

He had come to work, and to live by work, and the morning had nearly gone. It was, in one sense, encouraging to think that in a place of crumbling stones there must be plenty for one of his trade to do in the business of renovation. He asked his way to the workyard of the stonemason whose name had been given him at Alfredston; and soon heard the familiar sound of the rubbers and chisels.

The yard was a little centre of regeneration. Here, with keen edges and smooth curves, were forms in the exact likeness of those he had seen abraded and time-eaten on the walls. These were the ideas in modern prose which the lichened colleges presented in old poetry. Even some of those antiques might have been called prose when they were new. They had done nothing but wait, and had become poetical. How easy to the smallest building; how impossible to most men.

He asked for the foreman, and looked round among the new traceries, mullions, transoms, shafts, pinnacles, and battlements standing on the bankers half worked, or waiting to be removed. They were marked by precision, mathematical straightness, smoothness, exactitude: there in the old walls were the broken lines of the original idea; jagged curves, disdain of precision, irregularity, disarray.

—Thomas Hardy, *Jude the Obscure*

THE BUILDER IN STONE : A DISCOURSE

HE IS OBSESSED BY THOMAS HARDY'S *JUDE THE OBSCURE*

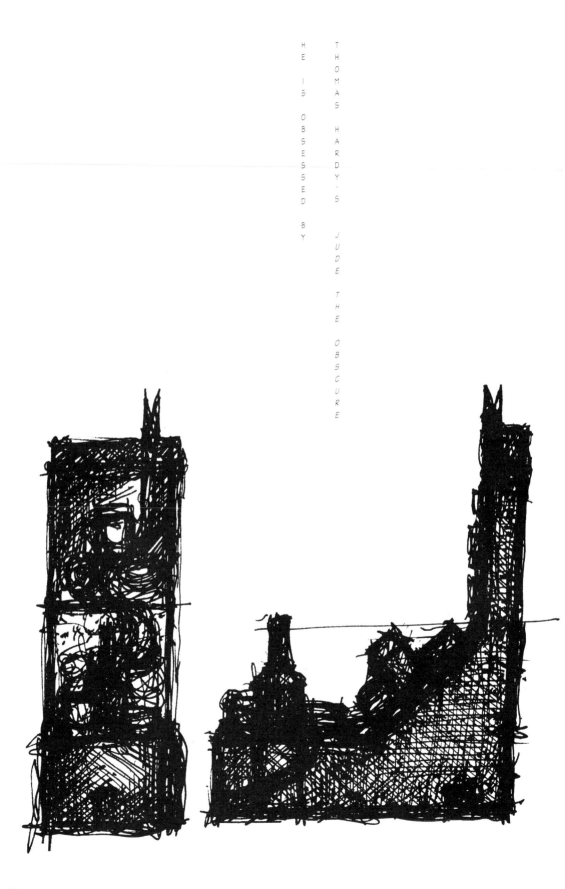

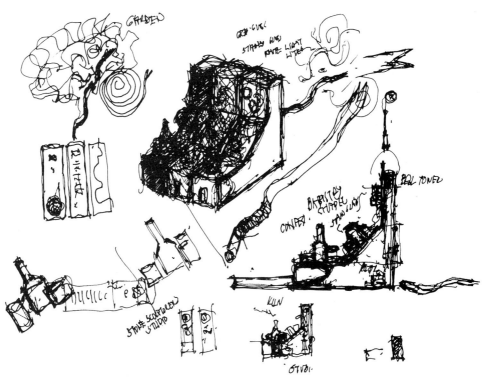

A stonemason lives next to a stone quarry and devotes his entire life to building three structures, one next to the other: first, his workplace, built of brick; second, his church, built of grey granite; third, his tomb, built of black granite. He also plants his garden hedge.

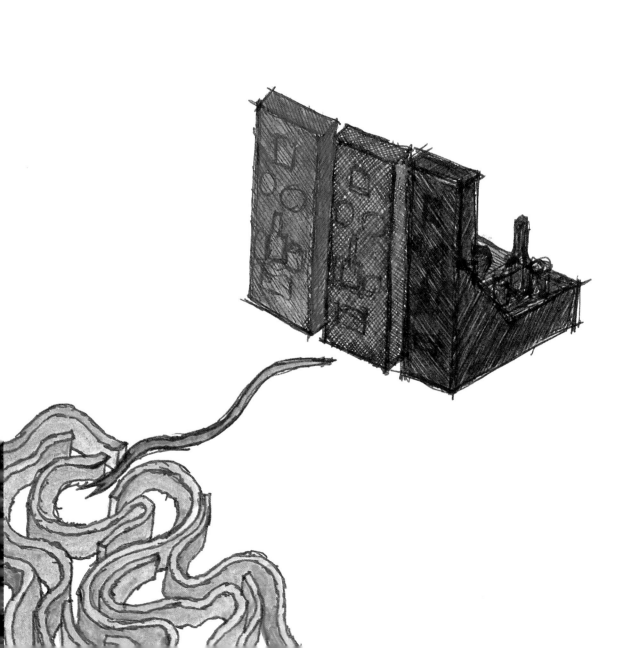

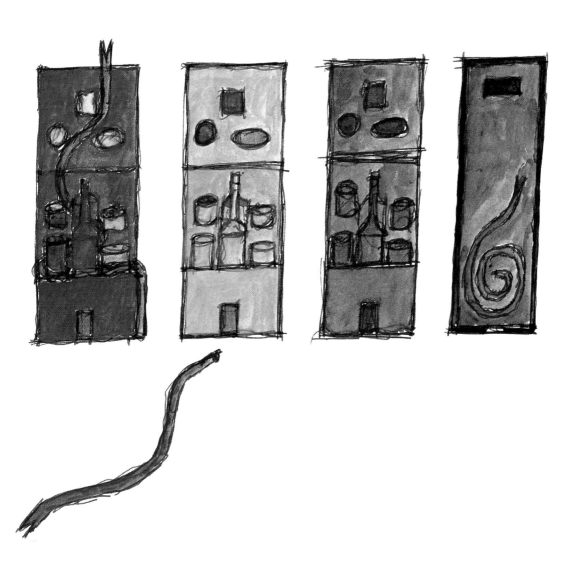

FIVE PIECES IN FOLK STYLE : ROBERT SCHUMANN

Sometime ago at home I was reading, seated in my leather chair, when my eyes chanced to look at the bookshelves which contained a modest library. This quiet observation produced two events/thoughts. One, I focused upon a book my wife had given me when we were students at The Cooper Union over 40 years ago. The book was a Phaidon publication of photos of the sculpture of Michelangelo. I opened the publication and looked at all the Pietàs Michelangelo had created from his early youth to his old age. The early Pietà was lovingly and precisely polished so that the surface of the marble gave off a satin glow which had the effect of crystallizing the air surrounding Mother and Son. The late Pietà from Michelangelo's old age was rough-hewn and had the tendency to thicken the air about the stone. Then I was struck with a revelation. During all the many years that Michelangelo had created his life-long Pietàs, that is, from youth to old age, the Pietàs' Mother Mary and Christ had aged along with Michelangelo.

He created his first Pietà when he was young. Christ and Mother Mary were depicted as being young. When he created his last Pietà he was very old. Christ and Mother Mary were depicted as being very old.

The second observation I made was that in my library, the volumes on the bookshelves had in fact aged with me. Although there were new volumes set in the bookshelves, the overall patina was of an aging. I liked that sense. Also what interested me was that many of the books' slipcovers, their outer protective skins, had disappeared; all that remained were the hard covers guarding the books' contents. Of course there were many slipcovers still on other books, some were battered from use and showed their worn life; they were like first skins soon to be shed, and of course, there were fresh new books exposing new life and joy.

I came across a few lines from songs by Purcell:

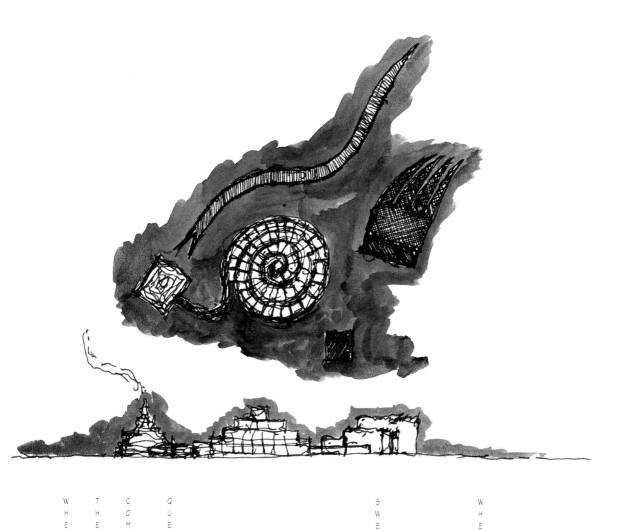

WHEN THE CLOTHES REMOVED

THEN BY ALL APPROVED

COMES THE FULL GREAT CUP

QUEEN HONORS GOOD SUCCESS

SWEETER THAN ROSES

A COOL EVENING BREEZE

WHERE O WHERE SHALL MY SOUL REPOSE

69

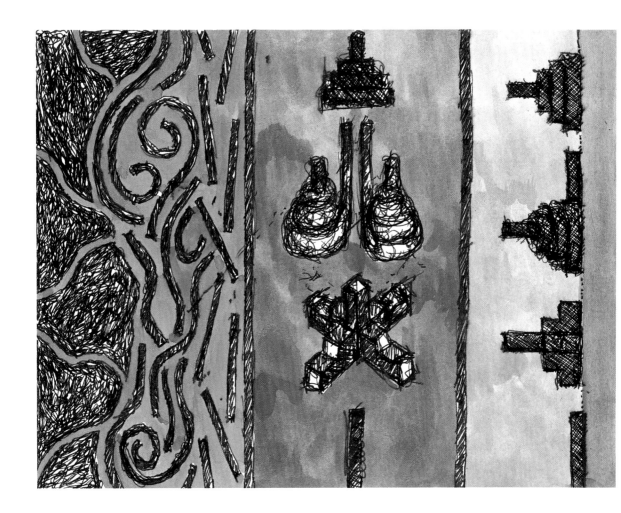

On the edge of a canal and a forest maze.

A
LAMENT

sight maximum extensions
from maximum compression
suction into a two-dimensional plane
the paradox of a planar flux
with a barreling in
explosions and implosions
simultaneously
the peripheral cords
of a drum
at the edge
suspended skin
creating a resonance
when struck volumetric sound
of haunting opacities
the solidity of granite cylinders
florentine columnar grays
beyond the specific gray
the density of material
aura of opaque radiation
blocks as slabs of weight
occupying sliding shearing
slipping nudging magnifying
evaporating limited space
impenetrable
tap them
with a wooden mallet
and
hear the echoes of sound
trapped in stone
entombment of space
holds a syncopation
the cries of muffled brass
playing on time's frame
spiraling to a point
celebrating a sadness

MEDUSA

no mythologies can elaborate
the pain at the roots
your horror comes
when the serpents sleep
it is then
that they become glazed
in salt
it is then too
that your mouth and eyes
open
simultaneously

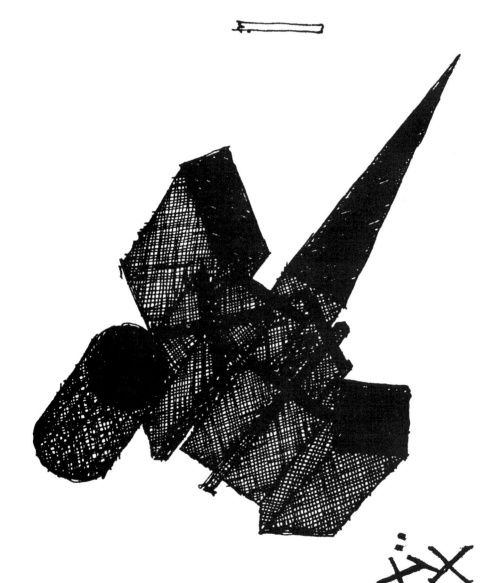

+ − x ÷

1. Of a line or surface in relation to another (curved) line or surface: touching, meeting at a point but not intersecting; in contact. 2. Divergent, erratic. 3. Touching, contiguous. 4. The upright pin fixed at the back of the keys of a clavichord, which upon depression of the key presses against the string and causes it to sound, acting also as a bridge to determine the pitch of a note.

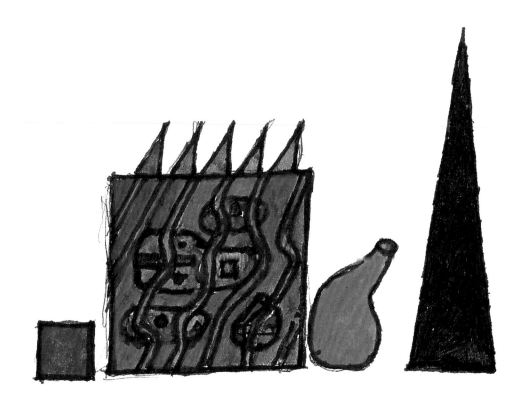

FIXED FLIGHT

D
E
V
O
U
R
I
N
G

A
N
G
E
L

The angel flew down
within range
and like a porcupine
releasing its needles
shot all his feathers
into the heart's blood
of the martyrs' torturers
to be spilled
staining the earth.

CHAPEL AND TOMBS

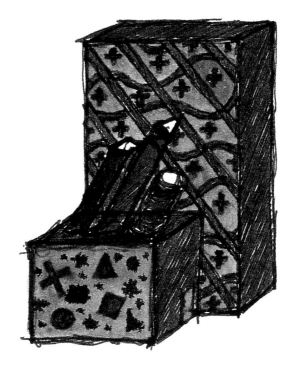

He was let down
into the tomb
the weight increased
at his descent
the hole in the cave
black beckoned.

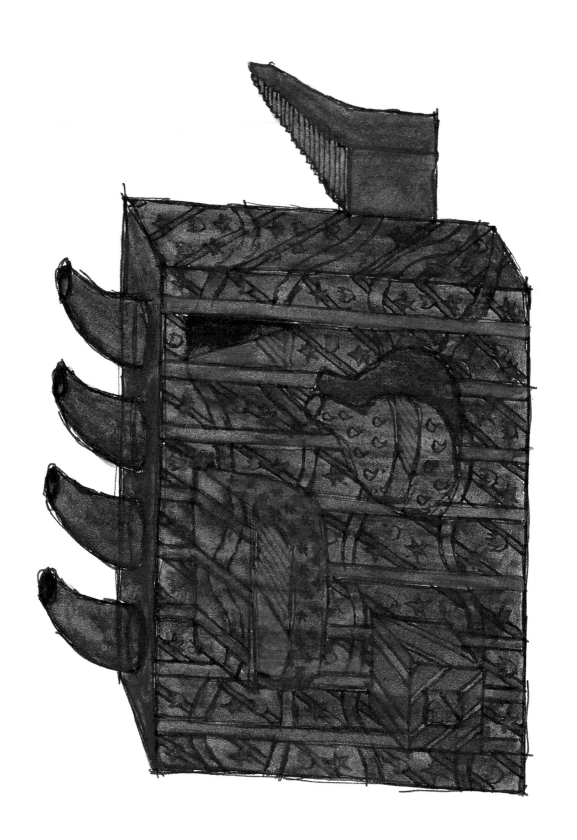

The thickness of solid sound.

SOLIDTHICKSOUND

There are two parts of sound: soundings and there is the liquid composition of sound (sound trapped in liquid). And I again bring up the late paintings of Braque, some of the greatest ever painted. One is of a man smoking a pipe, sitting in a wallpapered room with the bird of death, the bird flying through the wallpaper. As you keep looking at the painting, it is obvious that it is the room that is submerged in liquid.

While fishing, once in a while they find fish that they've never seen before. Remember that fish they brought up years ago? The galantheathauma—billions of years ago, they swam in the dark. As we submerge, the image is what gets most interesting. As you go down to the bottom of the depths, or follow this darkness that gets you to the deepest part, the darkest part, the part of the ocean that has the most pressure, there is a flock of luminous creatures that are filaments. And they give off light. I call them "soul filaments." They're so thin—thin, I guess, because of the pressure. They give off an internal light. That would be my description of the iridescence or phosphorescence of a thing.

A student, Paul Henderson, said, "You know that the lemon has inner light." I always remember going to Greece and walking during a moonlit night up a path to a grove of lemon trees. And I couldn't understand it but there was a luminosity given off by the lemons—in a moonlit night. Not an external luminosity, but an internal luminosity. Henderson showed me a lemon the other day. He cut a hole in the skin, a square cut, then held it to the lamp, and the light penetrated the lemon. The core of the lemon was giving off a light. Always believing the lemon skin is opaque and not porous, I suddenly discover that the skin of a lemon is made up of webbing that allows the light to penetrate the skin. You get the luminosity, an internal luminosity, not an external thing. I get a feeling that somehow the moonlight in Greece had some kind of an effect without cutting the lemon to give it an internal luminosity. The other interesting part was that he cut the lemon in half and because of the liquid, if you held it against the light you could see the seeds in there. It actually looks like a three-dimensional X-ray. Not a two-dimensional but a three-dimensional X-ray. So, I don't know what the sounds are in the bottom of the sea.

We went to Prague, Gloria and I, and entered the Baroque church off the main square; there was an organ playing. First of all, the architecture—the Baroque architecture was in its complexity but also in its simplicity. Because it's Baroque, everyone thinks it's complex, but it's not. Like a Proustian novel, it's clear. And then the organ. You couldn't tell where the music was coming from. It just filled this Baroque church. You look at the architecture. You look at the paintings in the church. You look at the sculpture in the church. You look at the liturgical conditions of the situations. And it was simply overwhelming. You understood what was meant by the phrase "music made in heaven."

It was *whole* in different stages. But the music, as a matter of fact, the music filled the silence of space. Music can be heard within, which gives it that aspect. But it was timeless. It worked out time.

HOUSE FOR THE KEEPER OF THE ARCHIVES ON PERSEPHONE

HOUSE OF THE DEAD

Death demands that houses have windows so that he can see simultaneously day and night.

Death is pleased when man cuts flowers. He sees the act as a premonition.

Death is nothing compared to life.

Death hates film negatives.

We never see the last card of death until it is over.

Death inculcates us with dread, then erases the r.

Death argues with God about the vertical while man lies horizontal.

Death's favorite color is the rose.

The poet's words are incomprehensible to death.

All souls implode when a woman dies; it is then that man's heart disappears.

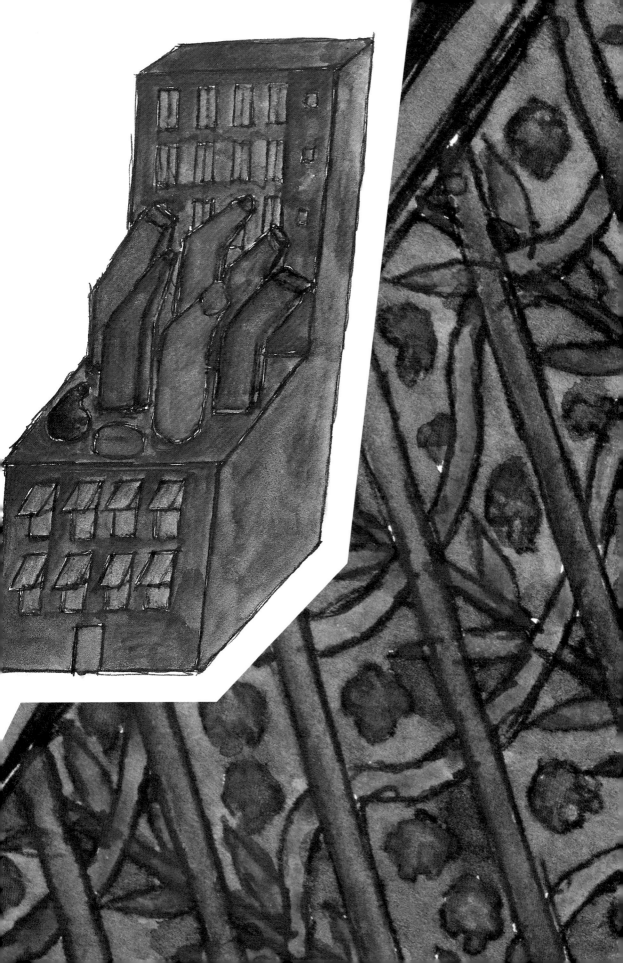

THEATER OF THE DEAD

There is a divinity moving you, like that in the stone which Euripides calls a magnet, but which is commonly known as the stone of Heraclea. For that stone not only attracts iron rings, but also imparts to them a similar power of attracting other rings; and sometimes you may see a number of pieces of iron and rings suspended from one another so as to form quite a long chain: and all of them derive their power of suspension from the original stone. Now this is like the Muse, who first gives to men inspiration herself; and from these inspired persons a chain of other persons is suspended, who take the inspiration from them. For all good poets, epic as well as lyric, compose their beautiful poems not as works of art, but because they are inspired and possessed.

—Plato

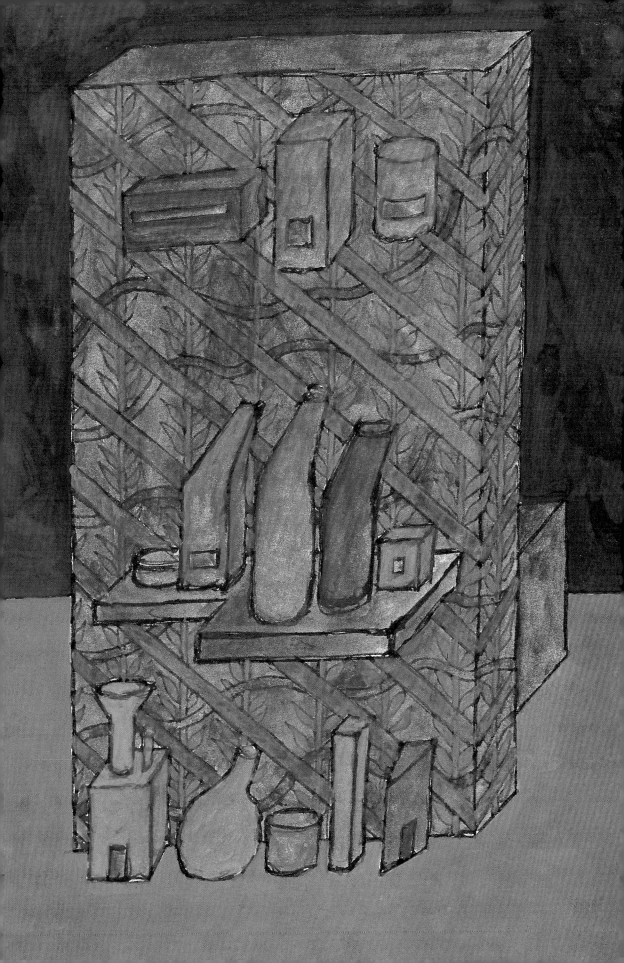

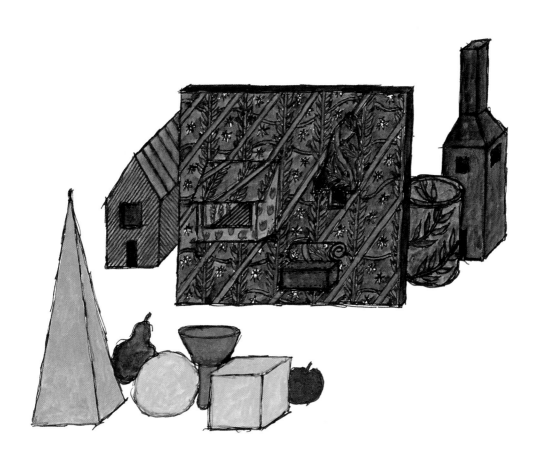

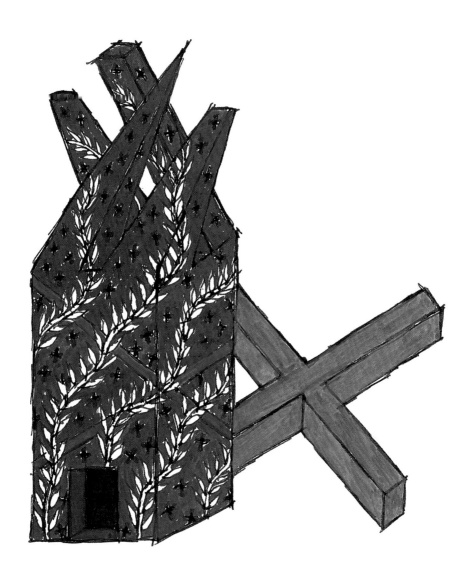

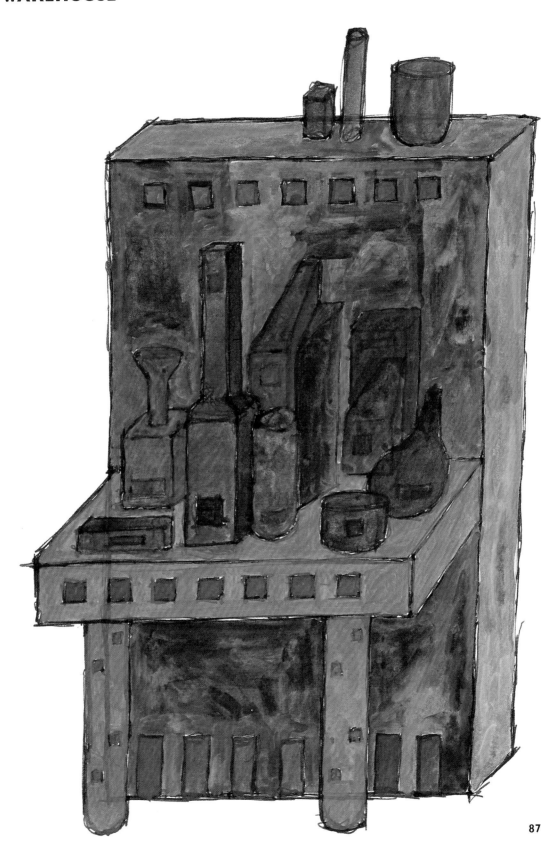

According to literature of [the medieval] period, which had strong ties with the Roman classics, the *pomarium* was the orchard where trees were planted in a quincuncial pattern and divided up according to their species. The *viridarium* was the place where evergreens grew (pine trees, cypresses, firs, laurels, and olive trees). It was the best place for protection from the heat of summer and the birds. The kitchen garden or herb meadow was the space dedicated to the cultivation and production of medicinal, culinary, and essential herbs: mint, sage, rosemary, thyme, basil, and rue. Roses, violets, lilies, jasmine, hyacinths, and lilac were grown in the flower beds. Medieval gardens were enclosed by fences because the area detracted from the wider agrarian context with its requirements of contemplation and special production. It was an area set apart for privileged uses. This circumscription, which is also symbolic and reverent, is multiplied inside the garden in the subdivision into sectors and beds. The garden was an infinite chessboard of various preciosities classified in an easily understandable and culturally acceptable way.

—Virgilio Vercelloni,
European Gardens: An Historical Atlas

CHURCH COURT GARDEN

The basic motif with which the medieval gardener worked was the rectangular plant bed. Rectangular beds are shown as early as the St. Gall plan and the neat planting in rows is a natural development out of the simple scattering of seed and scratching of the ground. This basic motif of the cube, repeated with the regular rhythm of the checkerboard, created a pattern implying infinite extension in space; however, the pattern was controlled by a strong frame, the garden wall, and frames within frames in the low walls, and planking of the beds. Following the line of the walls and paths, turf benches repeated and reinforced the regularity and rectangularity, the subdivisions and repetitions, as well as adding a three-dimensional interest. The mathematical clarity of the design, the geometric quality of the composition, the clear definition of parts and their orderly arrangement suggests inspiration from the Muslim world, or a continuity of Roman tradition.

—Marilyn Stokstad and Jerry Stannard,
Gardens of the Middle Ages

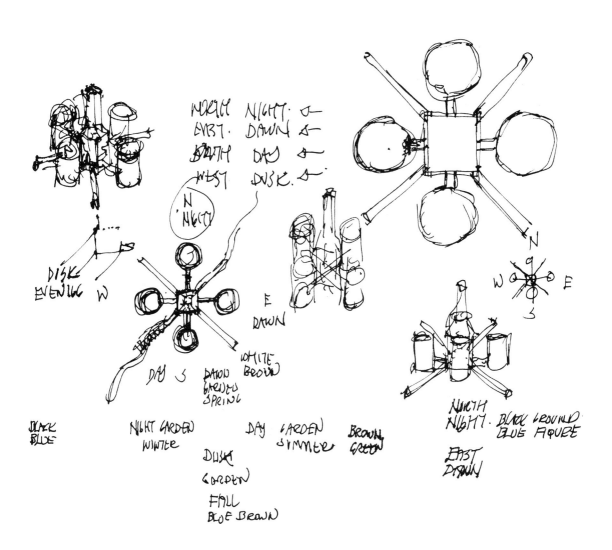

NORTH NIGHT.
EAST. DAWN
SOUTH DAY
WEST DUSK.

N
NIGHT

DISK
EVENING W

E
DAWN

DAY S

DAWN
GARDEN
SPRING

WHITE
BROWN

N

W E

S

NORTH
NIGHT. BLACK GROUND
BLUE FIGURE

EAST
DRAWN

BLACK
BLUE

NIGHT GARDEN
WINTER

DAY GARDEN
SUMMER

BROWN
GREEN

DUSK
GARDEN

FALL
BLUE BROWN

Painted cylindrical wall garden.

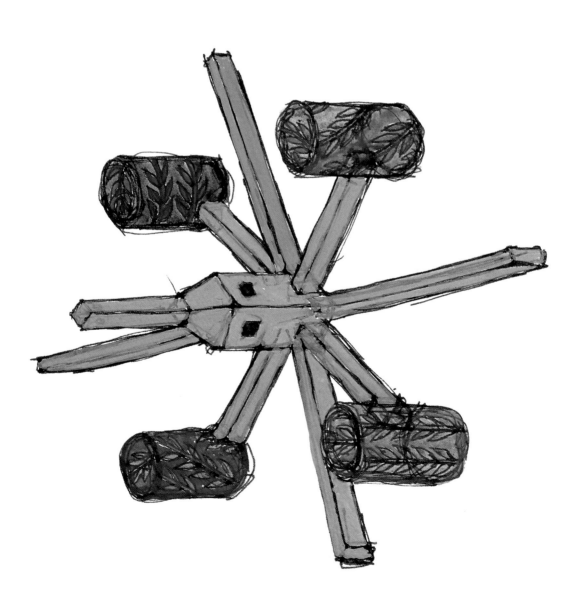

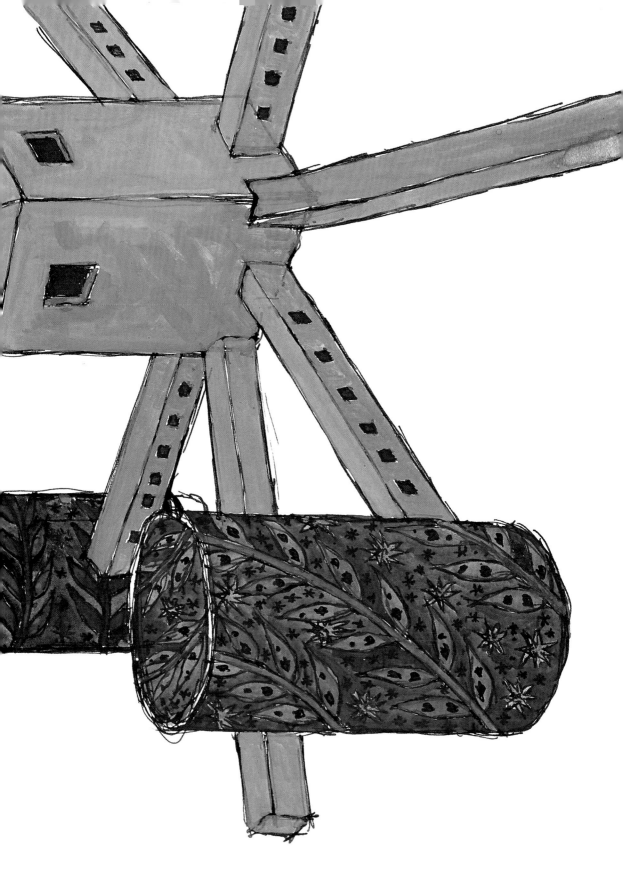

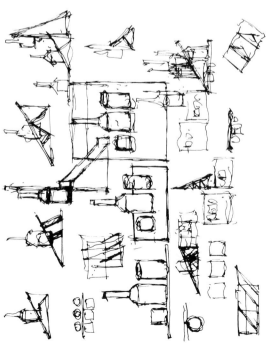

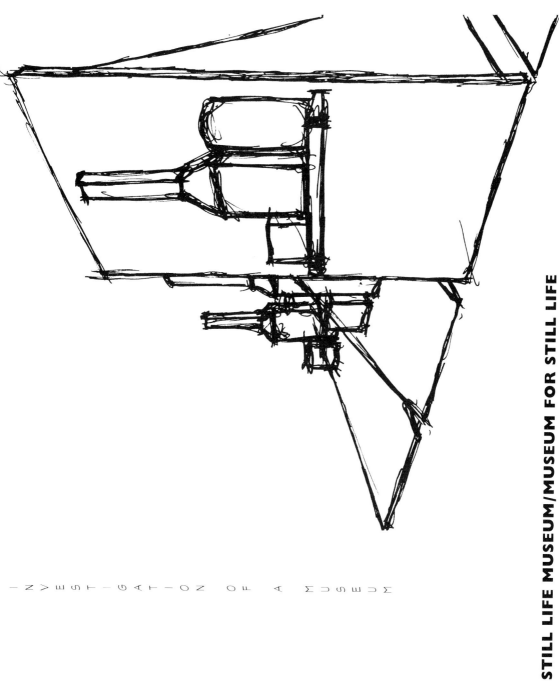

INVESTIGATION OF A MUSEUM

The granite pharaohs
plotting their own escape
from the museum
The pewter ibis
gliding through the Egyptian hall
fluorescent marble panther
leaping
on the glass faun
shattering it to shards
The ivory snake
blood-stained
by the slivers
The painting on Nefertiti's face
blistering
as hyenas suck
her wax tits
The flesh of man
a sacrilege
in such a place

STILL LIFE MUSEUM/MUSEUM FOR STILL LIFE

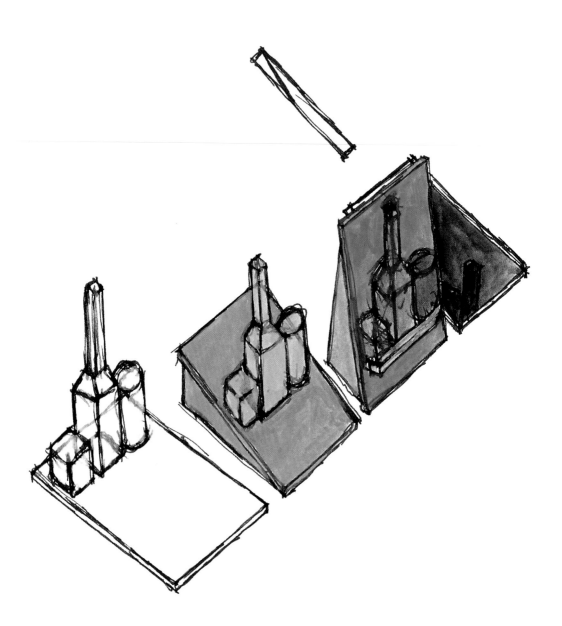

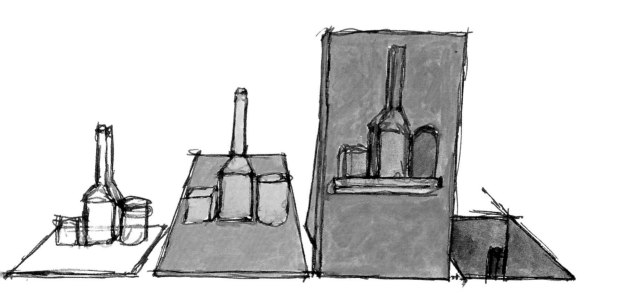

TWO CHAPELS FOR THE DEAD : HEAVEN-HELL/DAY-NIGHT

ENTOMBMENT OF CHRIST - DÜRER'S OBSESSION

He was let down
into the tomb
the weight increased
at his descent
the hole in the cave
black beckoned

He wanders through air
saturated with waiting souls
insufficient pressure
to overcome their vacancies
they adhere to his
thoughts' remoteness
and faintly pump up
their past sins

His visitations
opened up
as his wound
to Thomas's hand
his ascension
completed his
journey on earth
and commenced
his heavenly
judgments

flower and sword

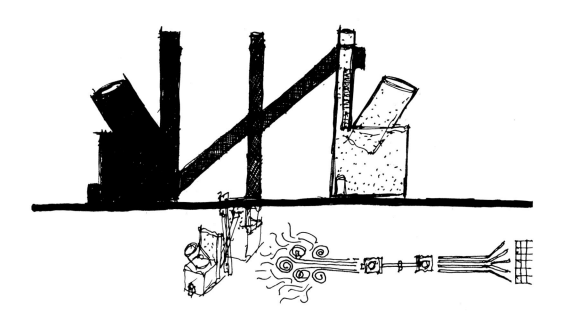

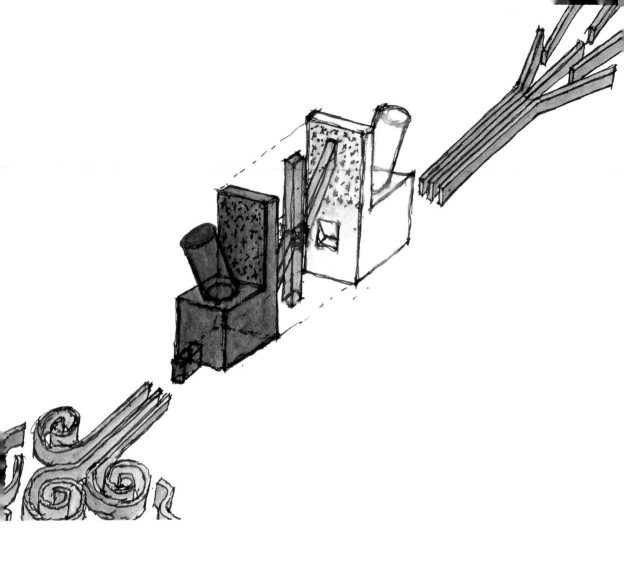

HEAVEN

HELL

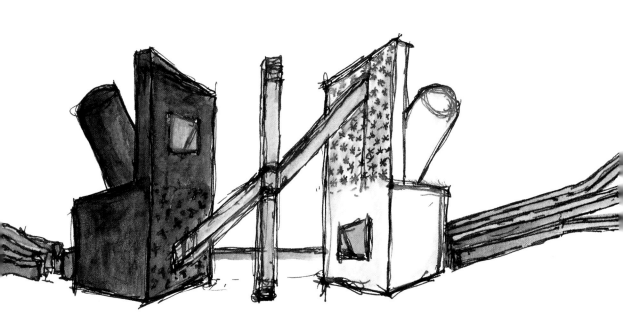

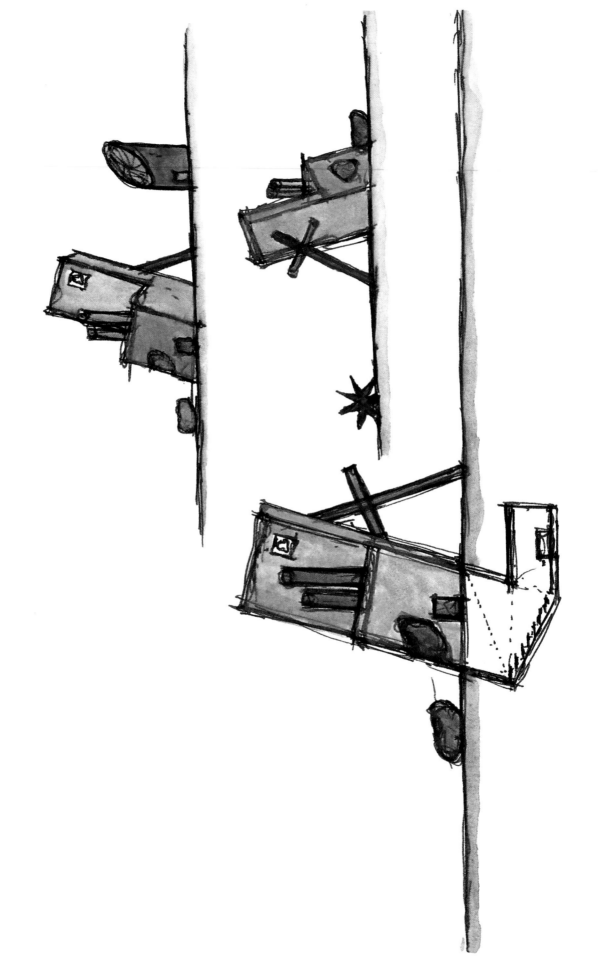

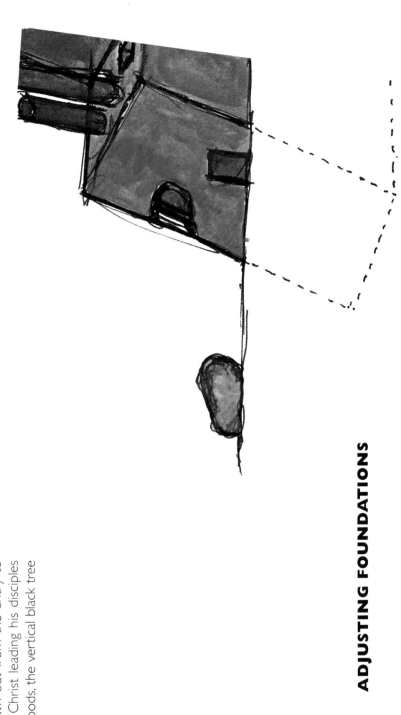

The memory of the moment in Pasolini's film *The Gospel According to St. Matthew* when the large boulder is blown out from the entry to Christ's tomb. Also, Christ leading his disciples through the dark woods, the vertical black tree trunks.

ADJUSTING FOUNDATIONS

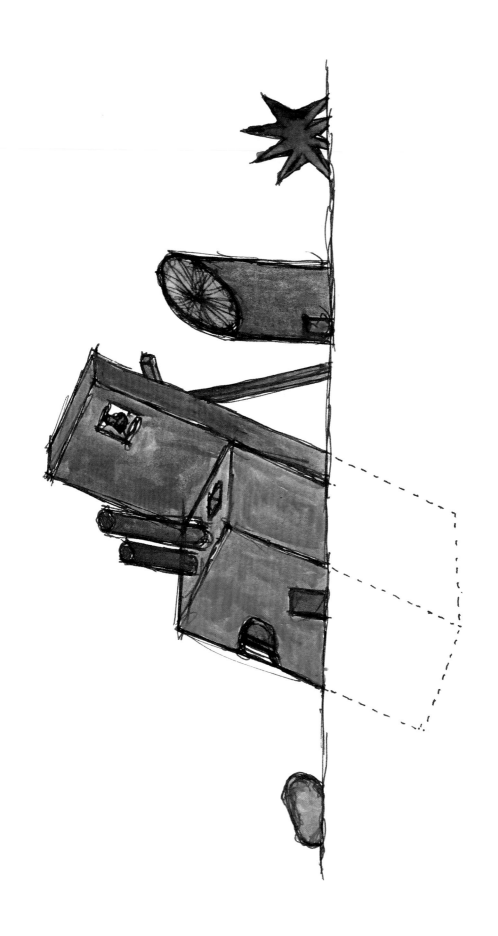

THE FALLEN STAR

CHURCH CRYPT

CRUCI-FORM SHORING

CYLINDRICAL LIGHT WELLS

SUSPENDED BELL

ENTRY DOOR

A STONE BLOWN OUT PERPENDICULAR TO GRADE

SKETCHES

GARDEN / MAZE
HOUSE / HOUSE

METAL / STARS

BLACK HOLE IN SKY

WALL PAPER /
TILE

SKETCHES

TWO CHAPELS FOR THE DEAD : WEST NORTH SOUTH EAST

W
E
S
T

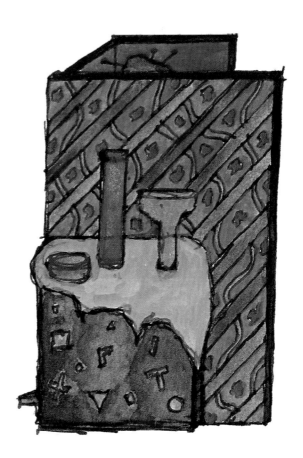

One indoor, one outdoor.

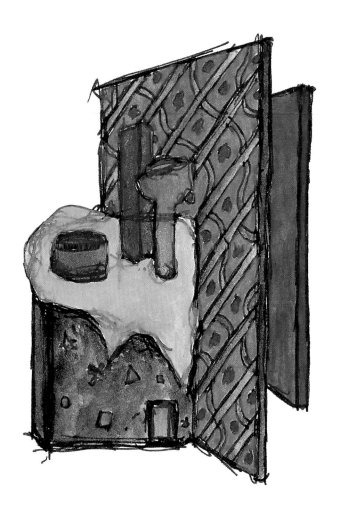

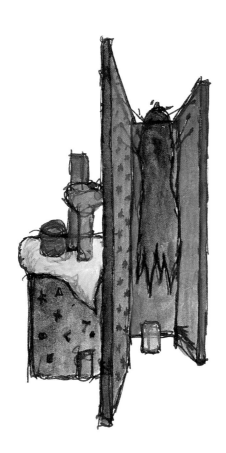

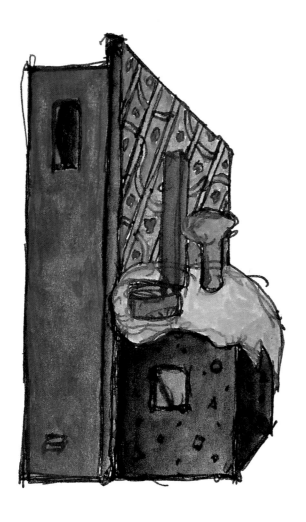

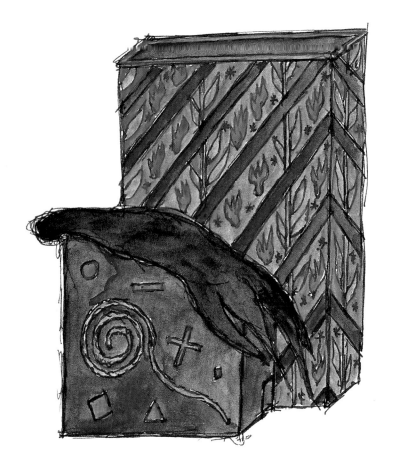

THE SACRED AND THE PROFANE

NIGHT THOUGHTS FOR DAY DREAMS

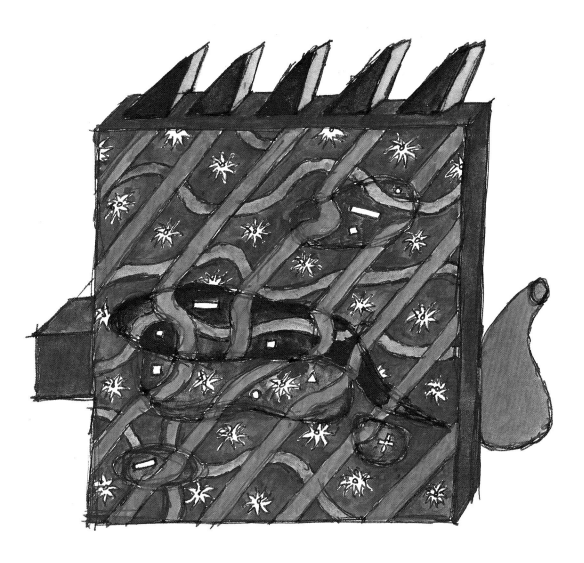

Black poplar was sacred to the Death-goddess at Pagae, and Persephone had a black poplar grove in the Far West.

—Robert Graves, *The Greek Myths*

CHURCH

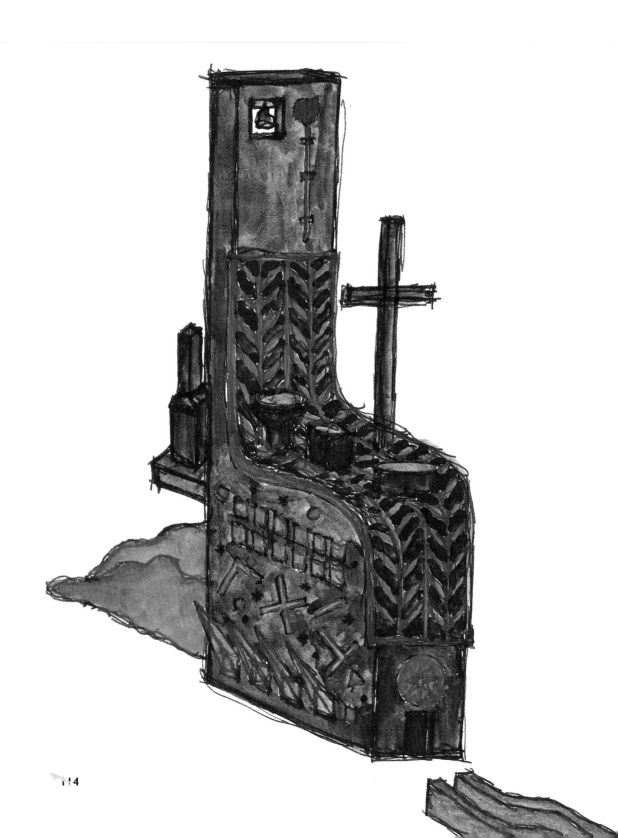

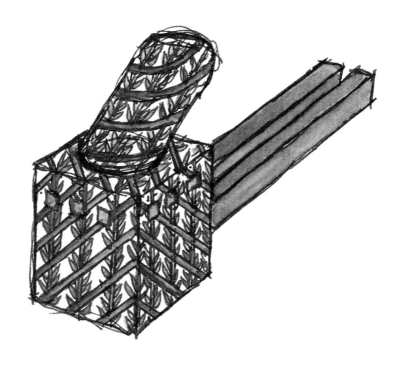

CHAPEL

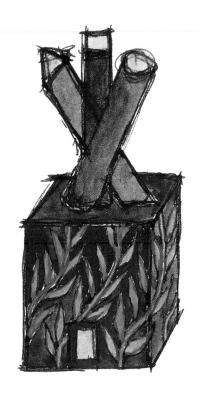

SANCTUARY

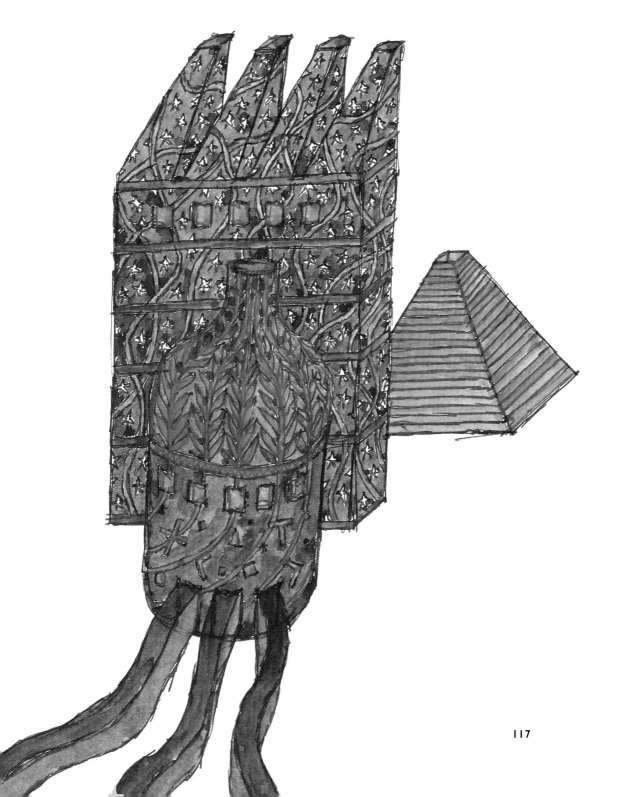

CHURCH CHAPEL STAR STONE

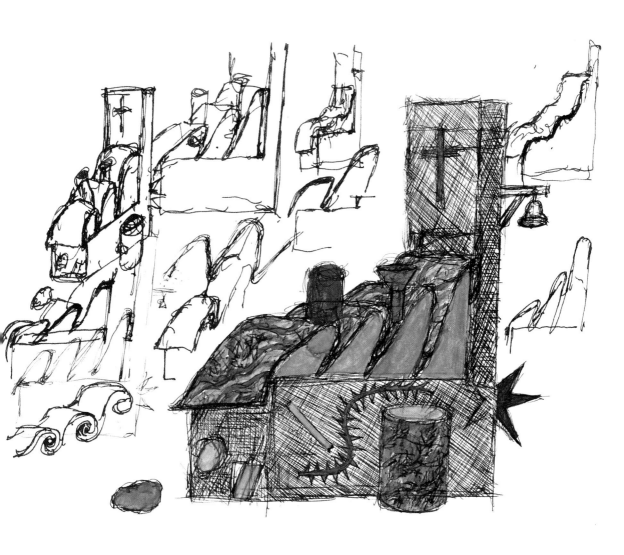

A
D
U
T
C
H

I
N
T
E
R
I
O
R

the mandolin intestines of
hollowed black crystals
slide against the internal
curvature
ultimately released through
the hole of stretched fibers
held
then diminished
in a tap

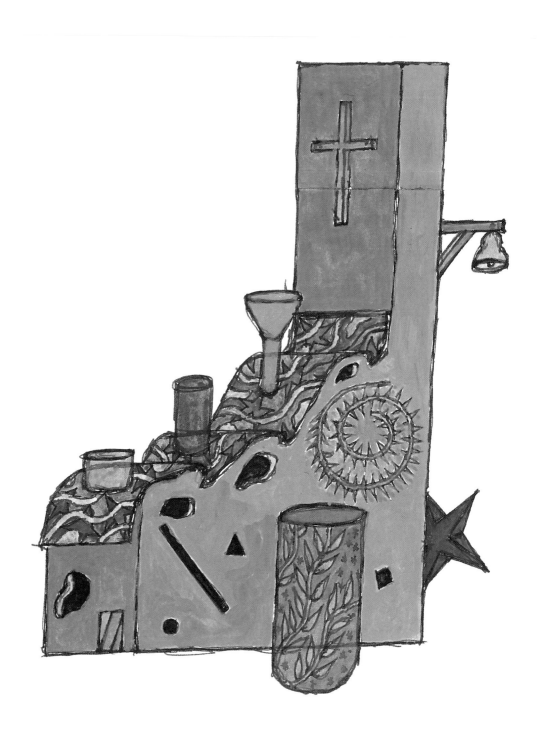

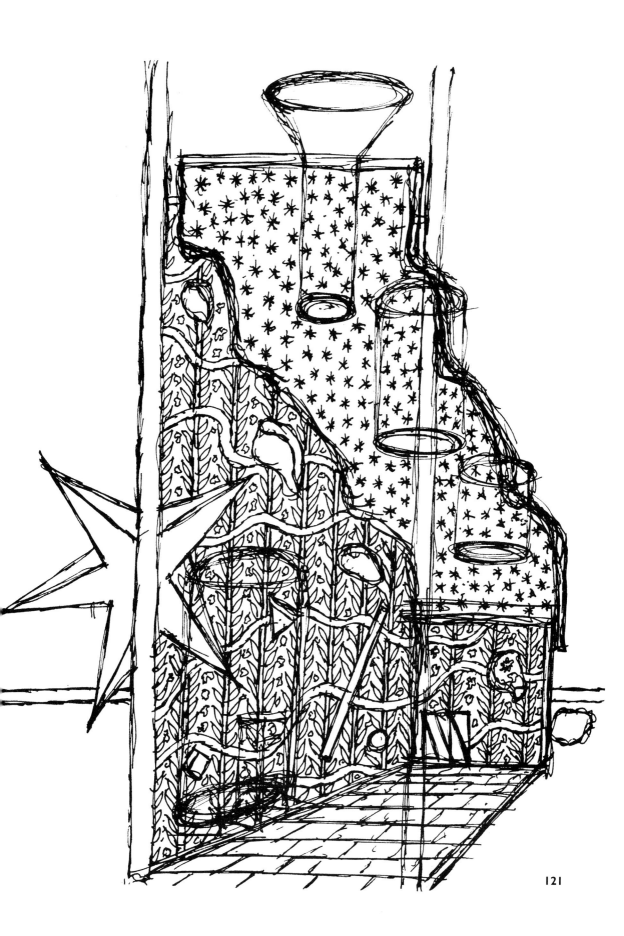

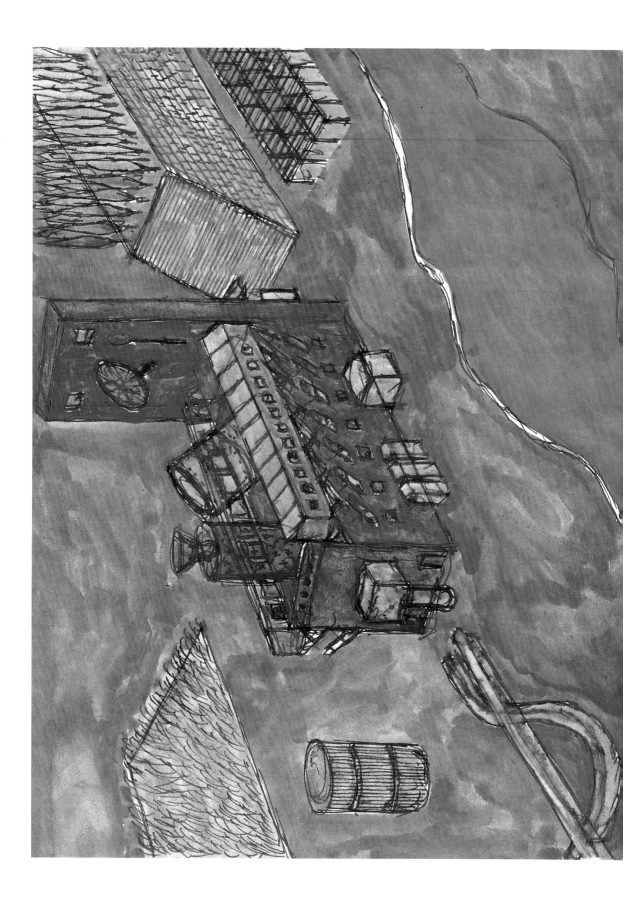

Site: between a stream and wheat field.

The cathedral entry faces a straight and serpentine corridor passage. The outdoor pulpit faces stepped seating that ends at a flat plane where cypress trees are planted. Below the roots of the cypress trees is a great hall where the tombs of the church fathers are placed. Between the stream and the exterior granite wall of the hall is a grape arbor. Between the wheat field and the straight/serpentine corridor is a large water-storage tank made of wood and metal.

ON
ROOF:

A large cylindrical metal skylight.
A baptistery within a roof courtyard.
A surrounding arcade/cloister where metal tombs of brothers are located.
Arcades supported and suspended on the sides of the cathedral.

Cantilevered from the exterior walls of the cathedral are a variety of chapels, confessionals, and cylindrical light wells. There is a pulpit, a crèche of angels, and a statue of Mary. Two bells and a rose window are suspended from the vertical volume.

RED CATHEDRAL AND A CRECHE OF ANGELS FLEW FROM THE WALL

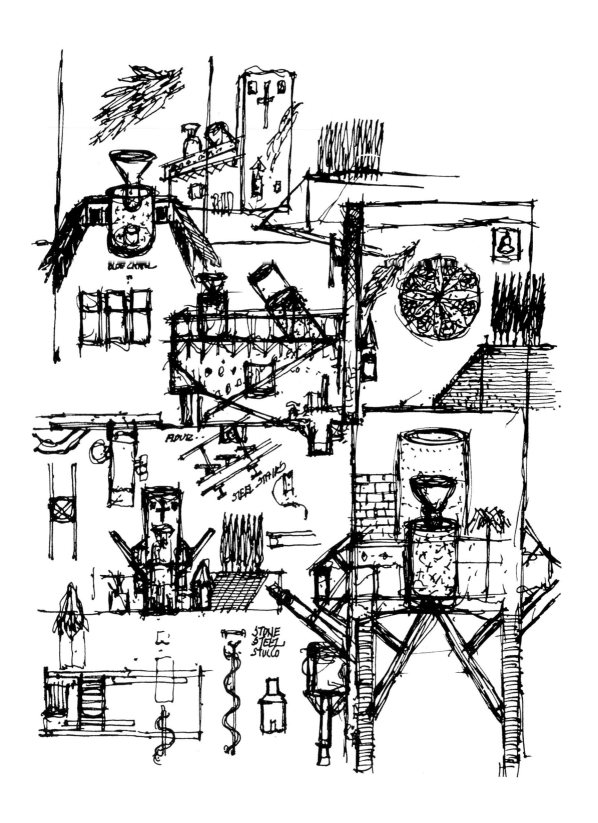

124

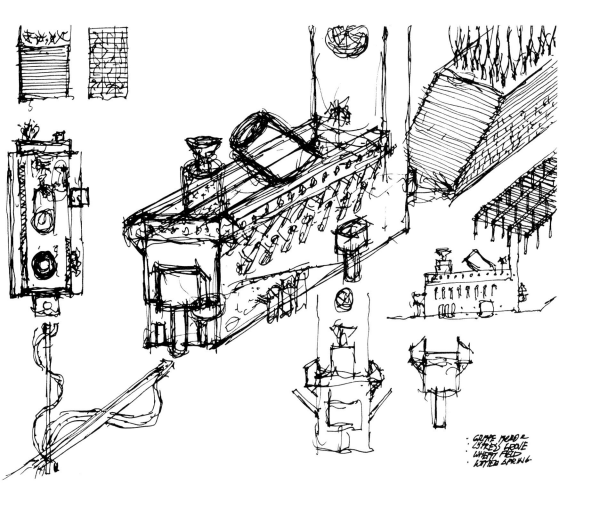

Choir, stations of the cross, holy water font, pulpit, altar, chapel entries, confessional entries, seating, roof baptistery support, and organ. There are two stairs ascending to the roof cloister, one on each side of the cathedral. I first saw this interior double stair at the cathedral in Trento.

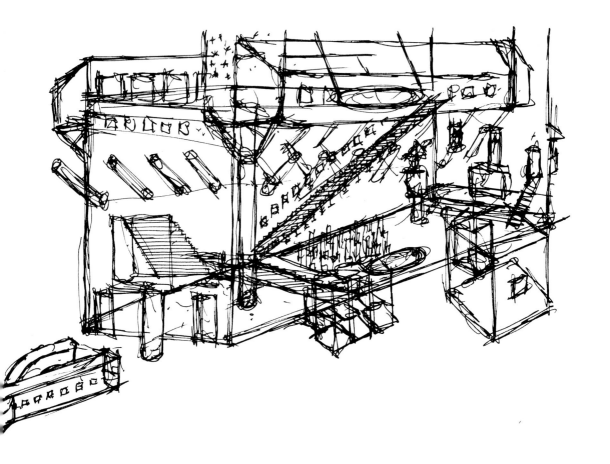

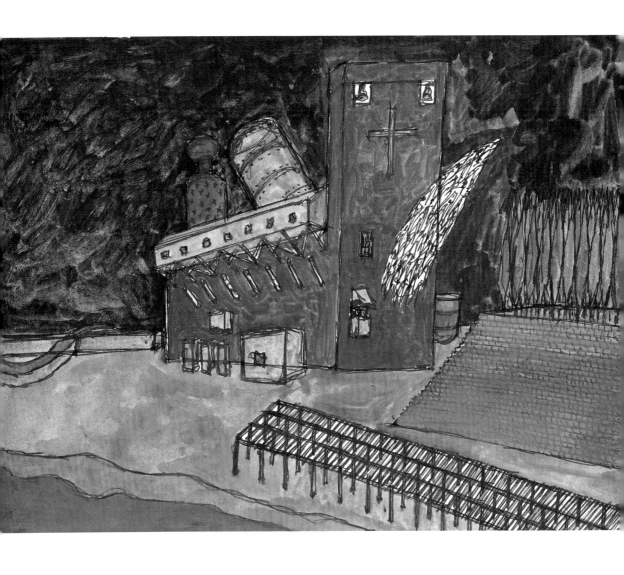

A PAINTER'S HOUSE

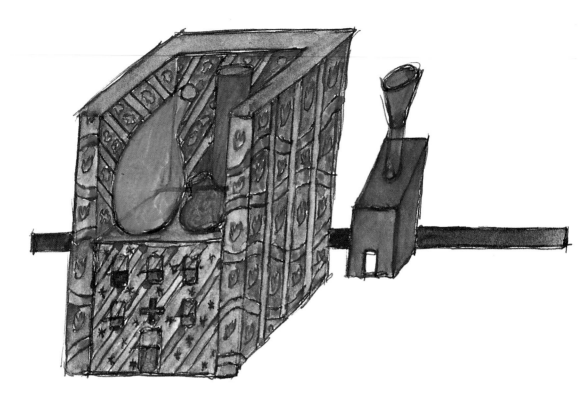

The Alhambra, of course, from the peculiar circumstances of its history, is a strong-hold for popular fictions of the kind, and various relics dug up from time to time have contributed to strengthen them. At one time an earthen vessel was found containing Moorish coins and the skeleton of a cock which according to the opinion of certain shrewd inspectors must have been buried alive. .At another time a vessel was dug up containing a great scarabaeus or beetle of baked clay, covered with Arabic inscriptions, which was pronounced a prodigious amulet of occult virtues. In this way the wits of the ragged brood who inhabit the Alhambra have been set wool gathering, until there is not a hall or tower or vault of the old fortress that has not been made the scene of some marvelous tradition.

—Washington Irving, *Tales of the Alhambra*

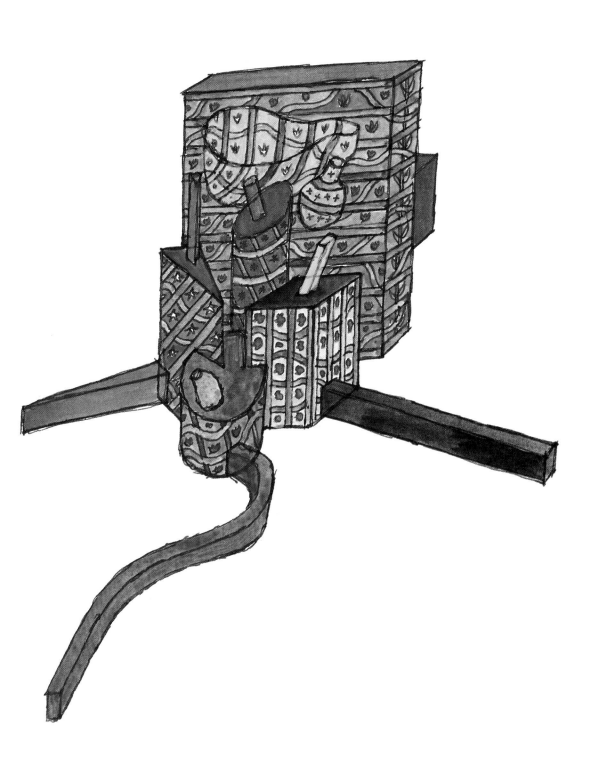

LIBRARY FOR STILL LIFES

CATHEDRAL

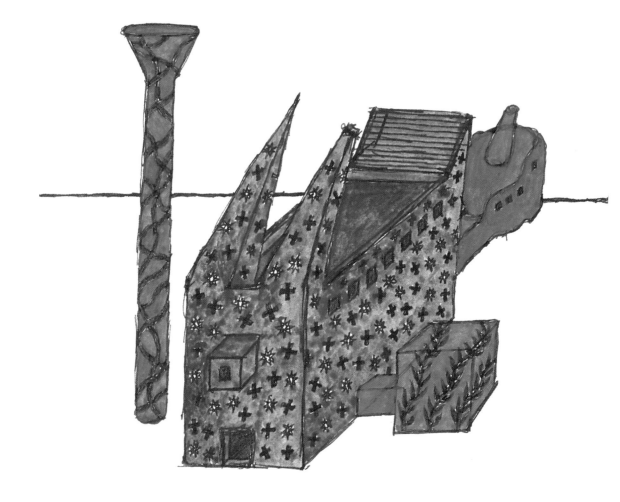

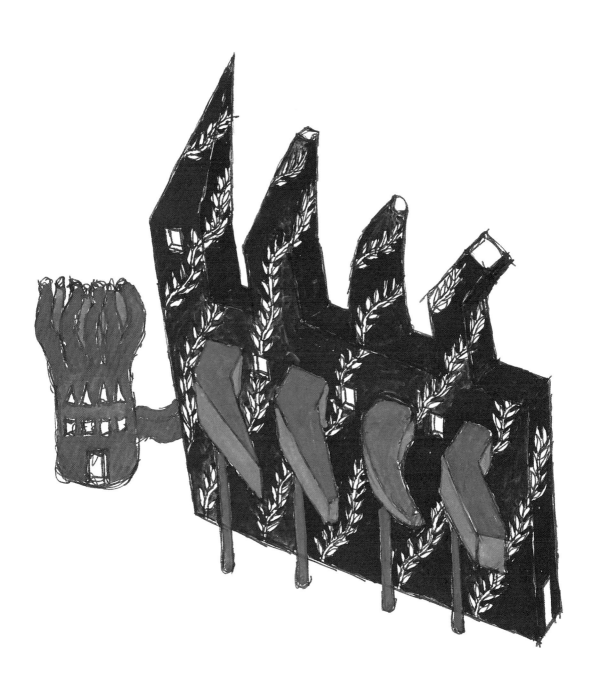

CHURCH AND BAPTISTERY

They were marching through a kind of large passage bordered by two chains of reddish-colored hillocks, when their nostrils were greeted with a nauseous odor, and they thought that they could see something extraordinary on the top of a carob-tree: a lion's head reared itself above the leaves.

They ran thither. It was a lion with his four limbs fastened to a cross like a criminal. His huge muzzle fell upon his breast, and his two fore paws, half hidden beneath the abundance of his mane, were spread out wide like the wings of a bird. His ribs stood severely out from beneath his distended skin; his hind legs, which were nailed against each other, were raised somewhat, and the black blood, flowing through his hair, had collected in stalactites at the end of his tail, which hung down perfectly straight along the cross. The soldiers made merry around; they called him consul, and Roman citizen, and threw pebbles into his eyes to drive away the gnats.

But a hundred paces farther on they saw two more, and then there suddenly appeared a long file of crosses bearing lions. Some had been so long dead that nothing was left against the wood but the remains of their skeletons; others which were half eaten away had their jaws twisted into horrible grimaces; there were some enormous ones; the shafts of the crosses bent beneath them, and they swayed in the wind, while bands of crows wheeled ceaselessly in the air above their heads. It was thus that the Carthaginian peasants avenged themselves when they captured a wild beast; they hoped to terrify the others by such an example. The Barbarians ceased their laughter and were long lost in amazement. "What people is this," they thought, "that amuses itself by crucifying lions!"

—Gustave Flaubert, *Salammbô*

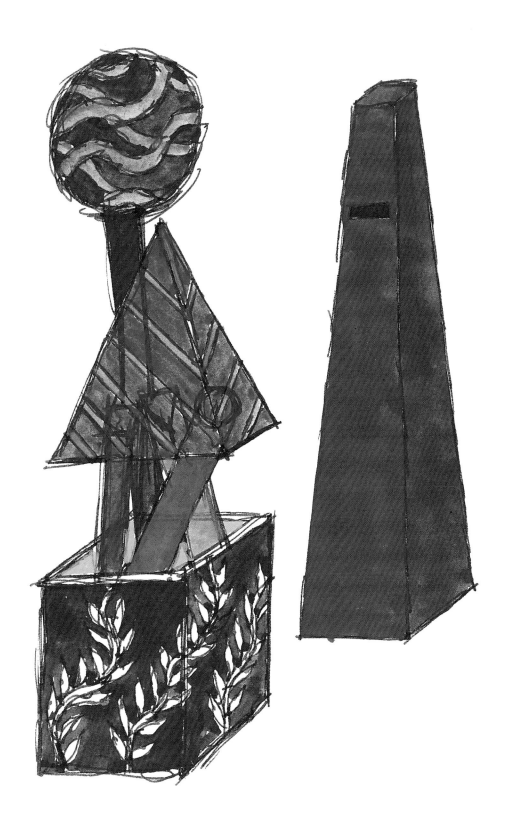

The problems of point-line-plane-volume, the facts of square-circle-triangle, the mysteries of central-peripheral-frontal-oblique-concavity-convexity, of right angle, of perpendicular, of perspective, the comprehension of sphere-cylinder-pyramid.

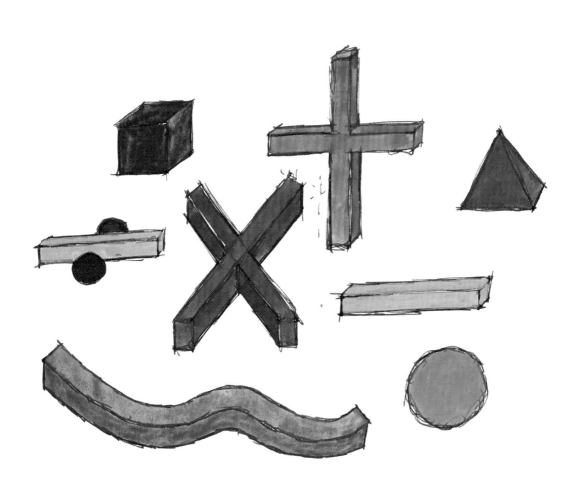

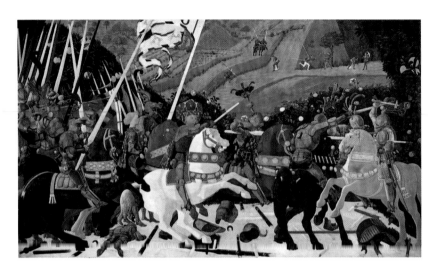

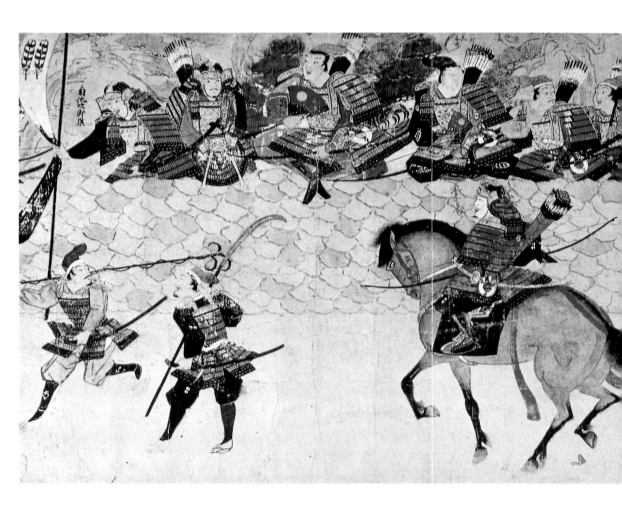

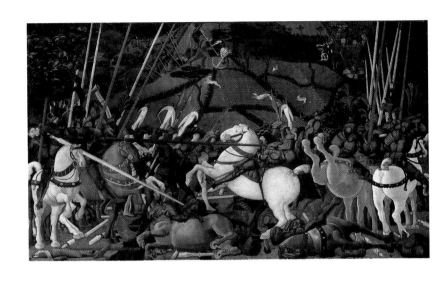

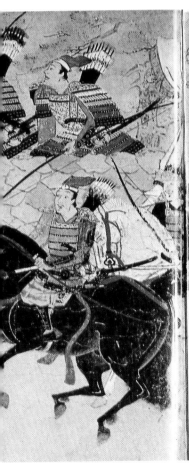
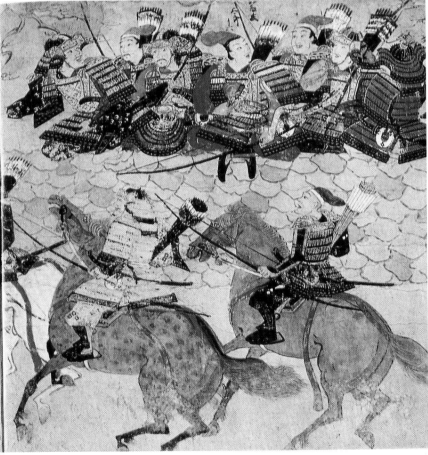

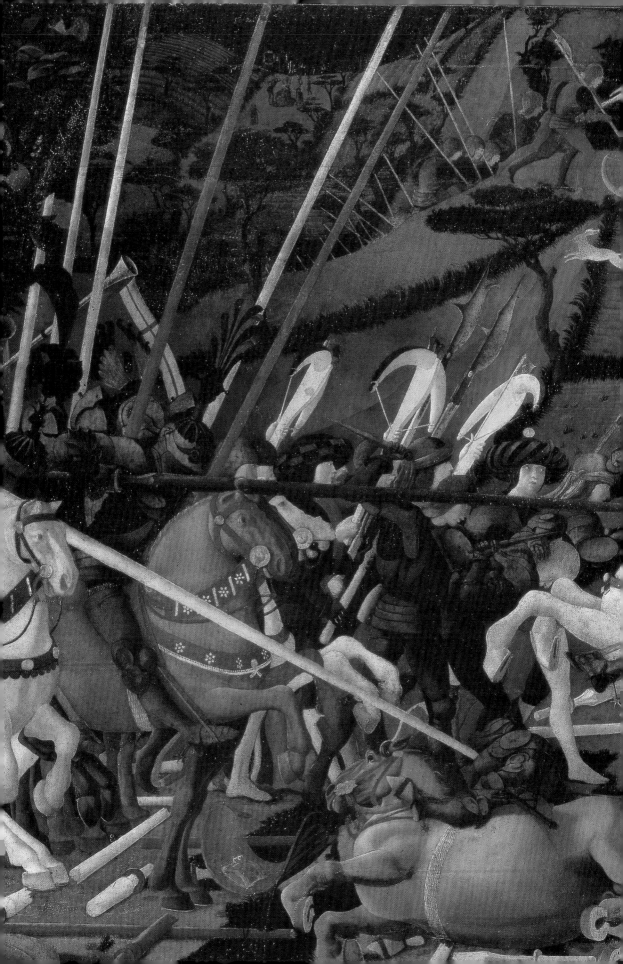

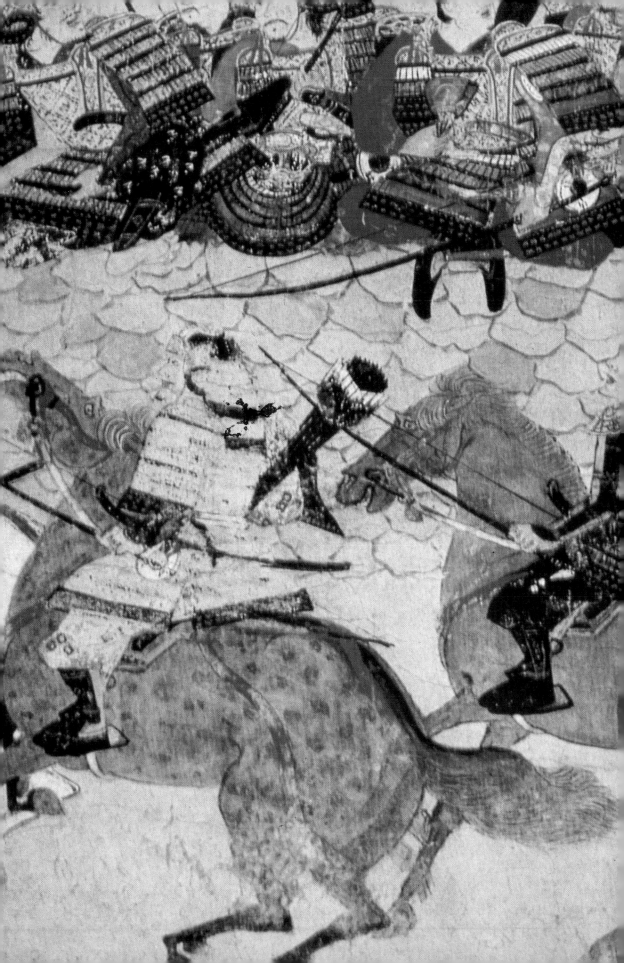

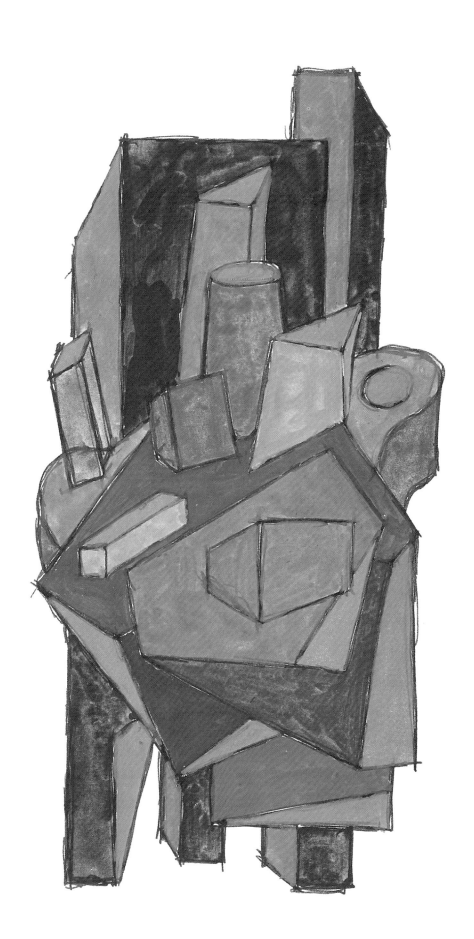

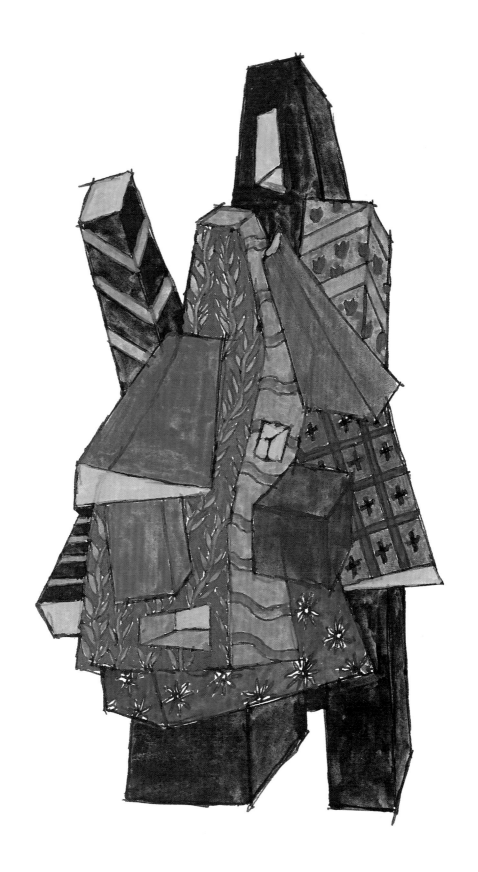

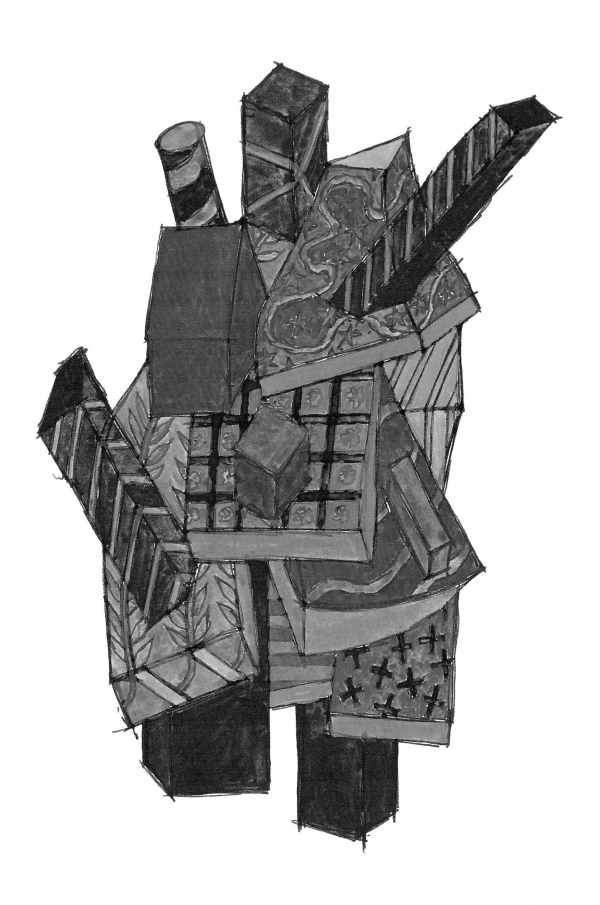

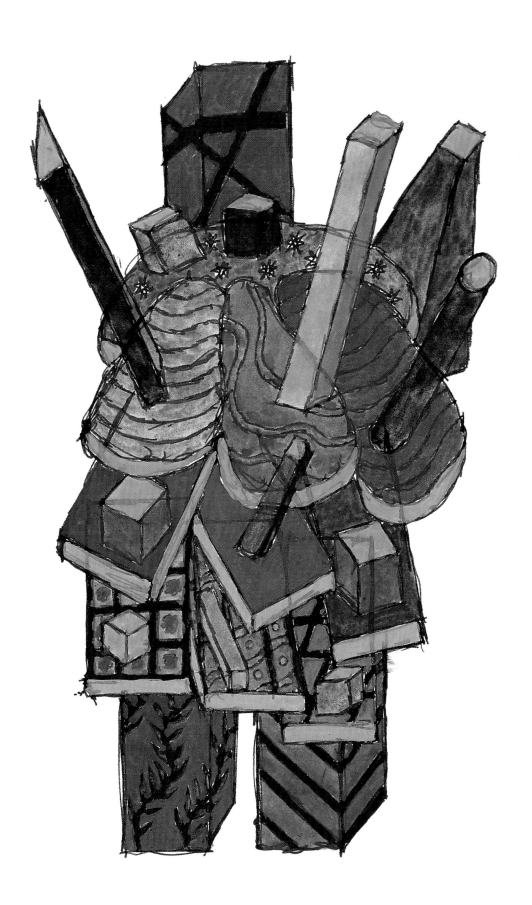

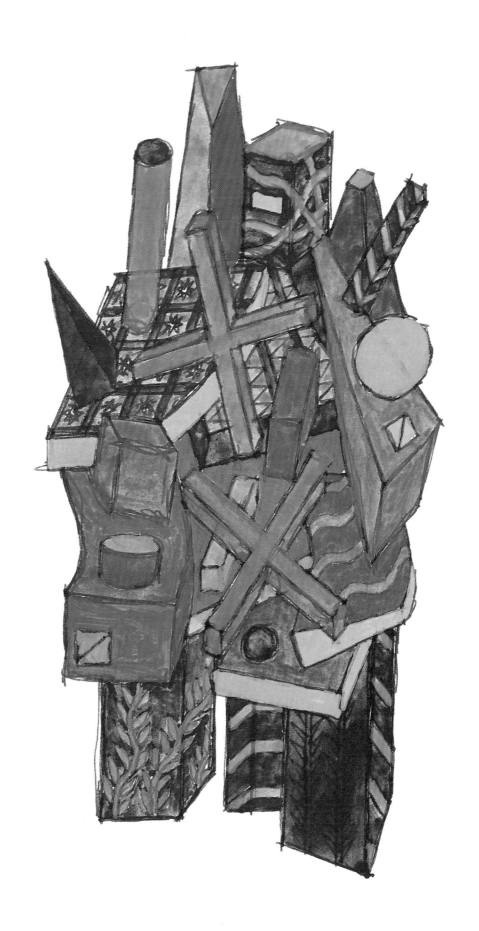

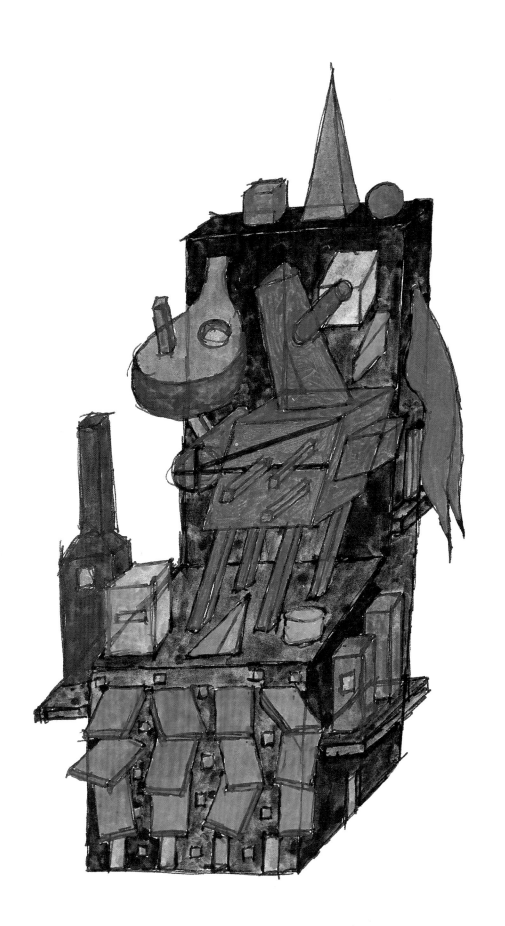

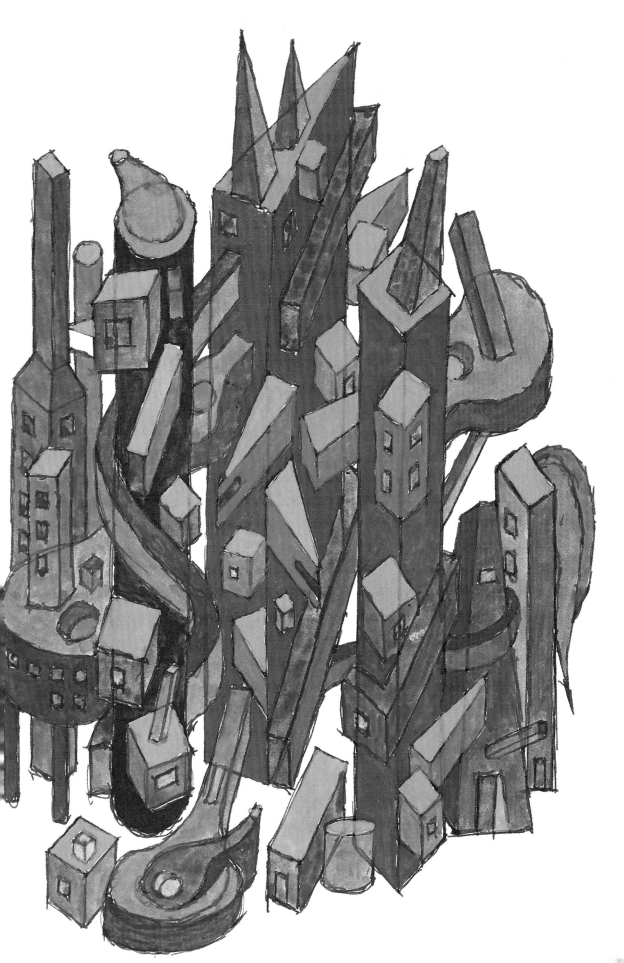

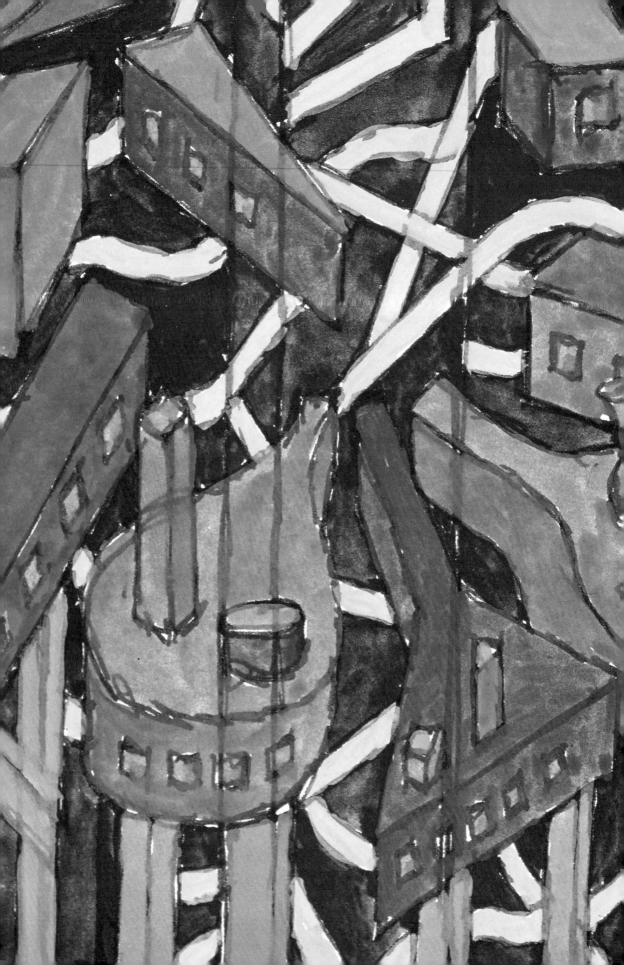

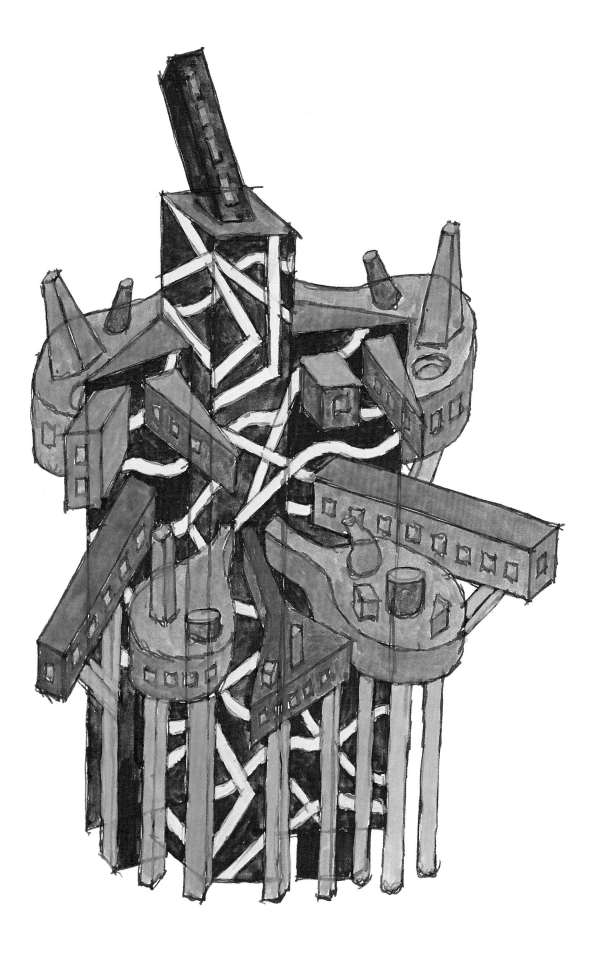

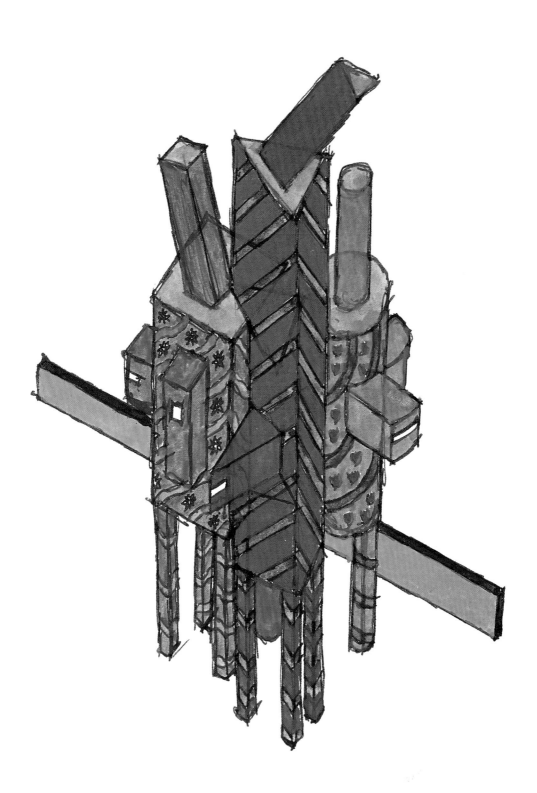

George related the events of that tragic winter. There occurred a sudden, rapid drop in temperature and the peculiar fact of the Landwehr Canal freezing during the early moments of dawn. Flocks of crows had landed on the canal during the night, completely covering the water. Somehow their claws had frozen into the ice. The sight confronting the Berliners was that of white slabs of ice moving in slow motion within the confines of the canal walls as the birds were frantically flapping their wings. Their legs were being stretched to the limit trying to release themselves from the frozen water that encased their claws. The shock was intensified by the observation that although the beaks of the birds were moving up and down no sound was emitting into the morning air.

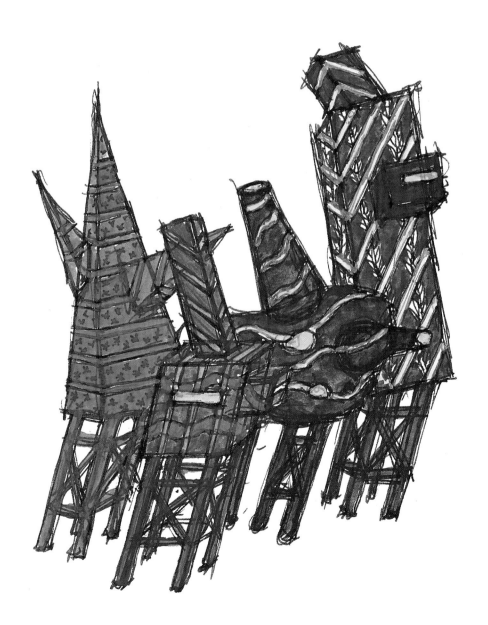

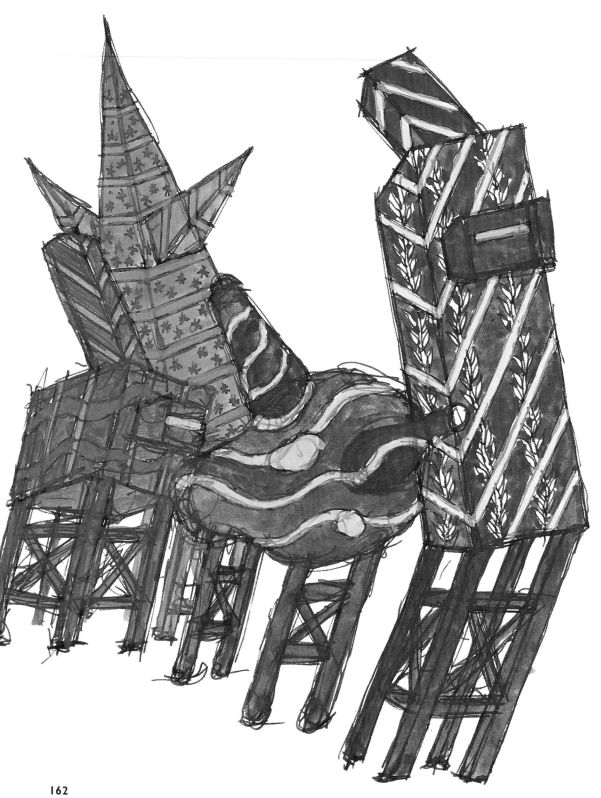

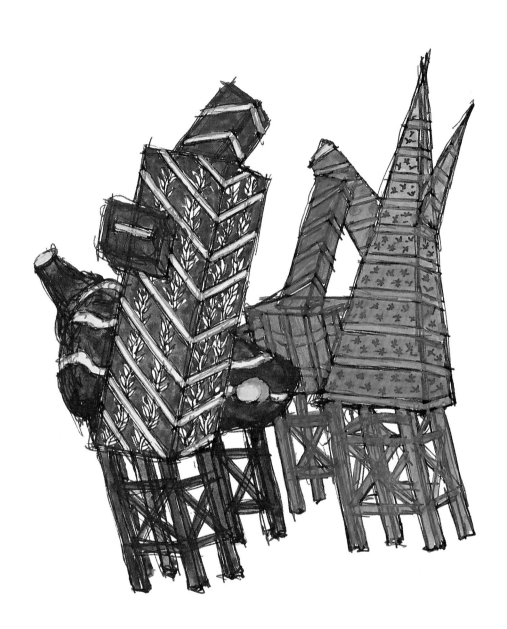

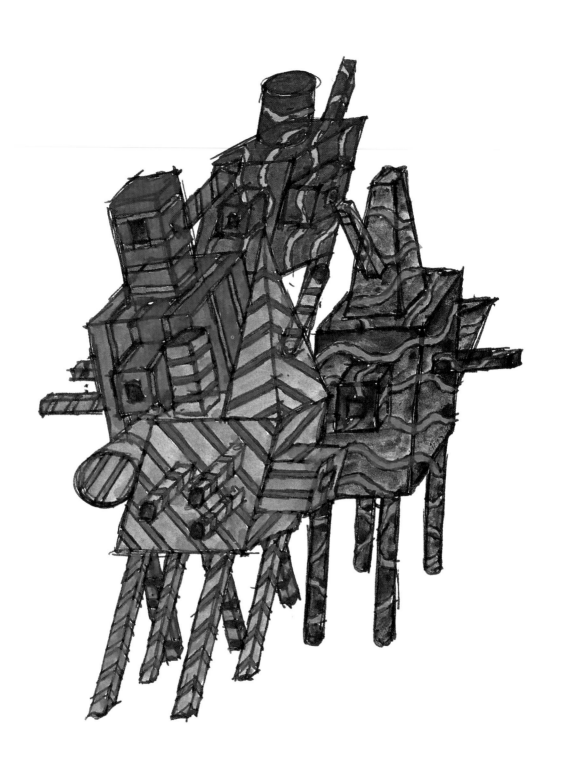

GEOMETRIC FLOWERS

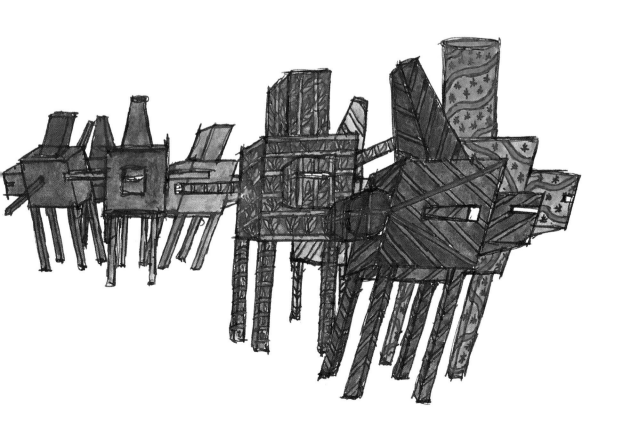

CHURCH

ON ROOF: WINE STORAGE WATER STORAGE FLOUR STORAGE

PEWTER ROOF OF ZINC LEAD

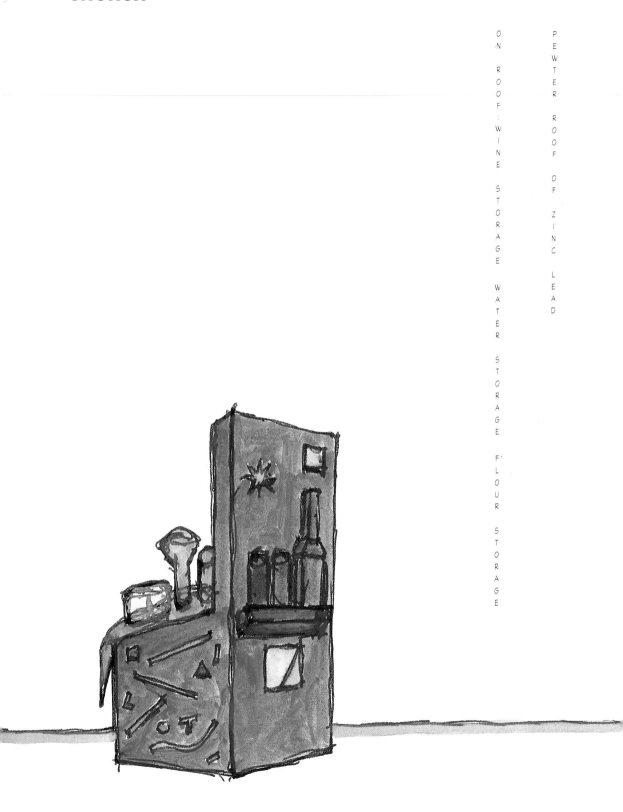

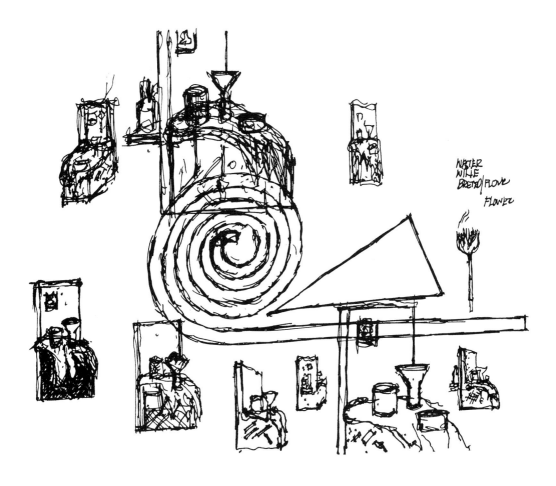

On the extended high element are an enclosed stair, a bell, and a metal rose for burning incense. A small chapel and confessionals are cantilevered. Two facades have sepia stained glass.

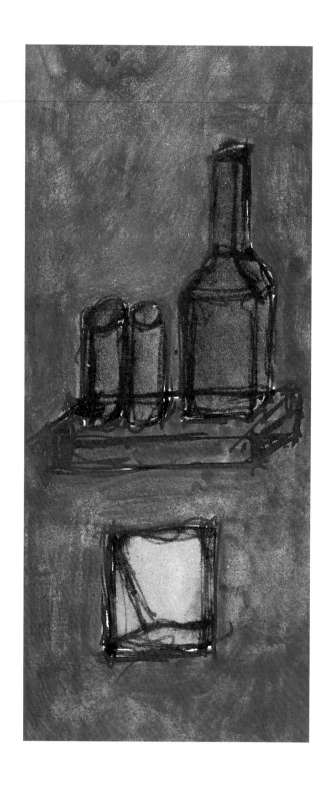

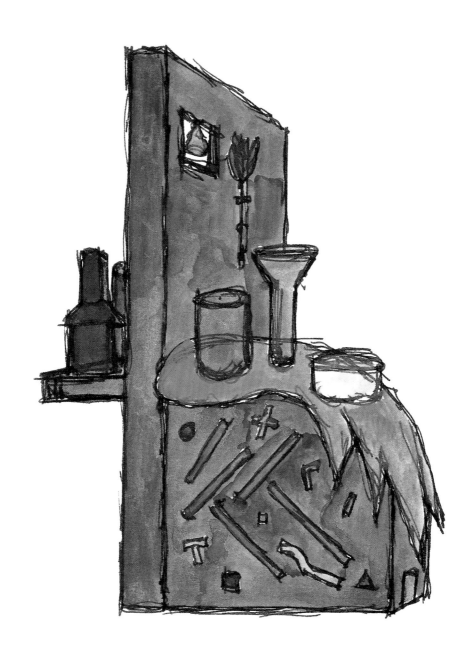

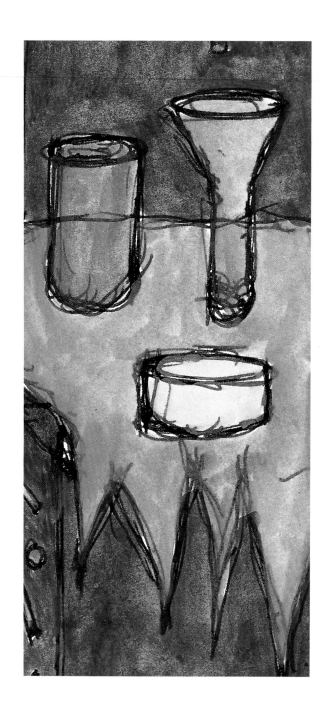

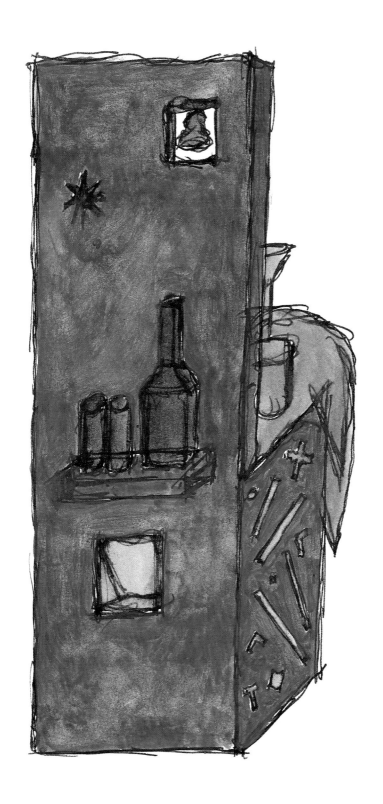

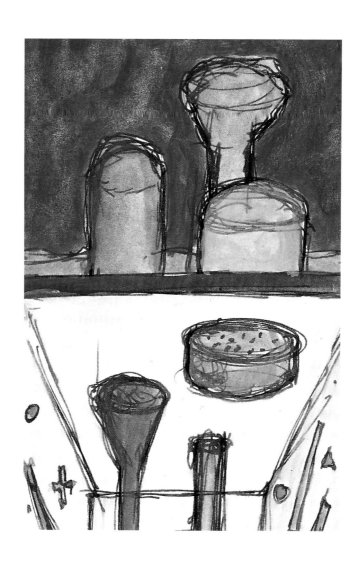

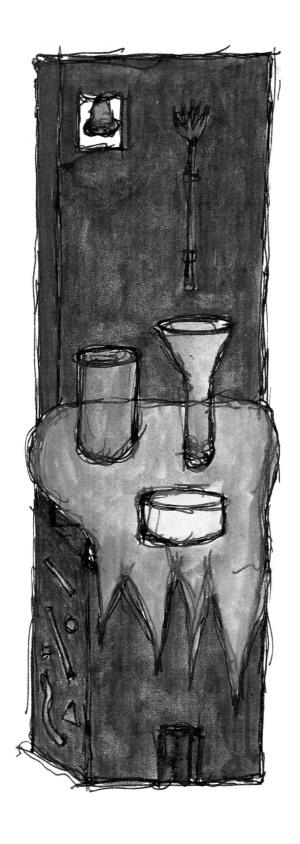

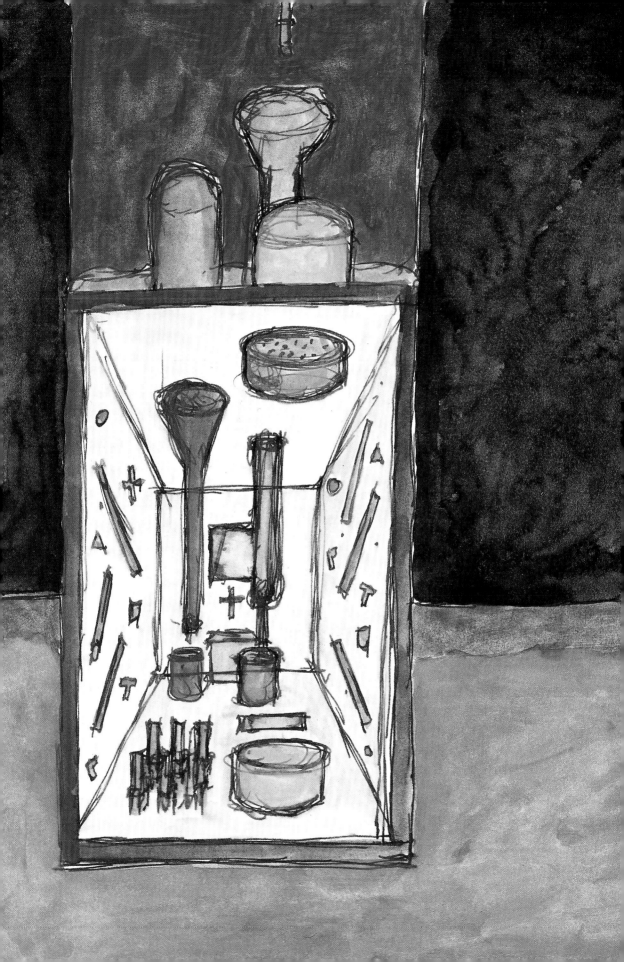

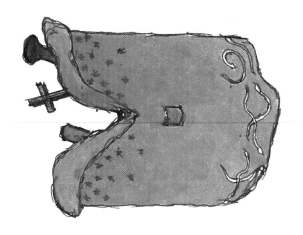

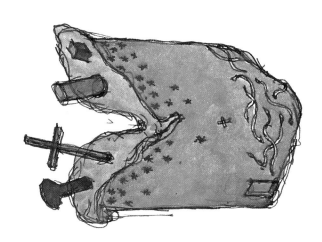

SEA SERPENTS

NIGHT METAL STARS

EARTH

WATER

STONE

FLOUR

WATER

WINE

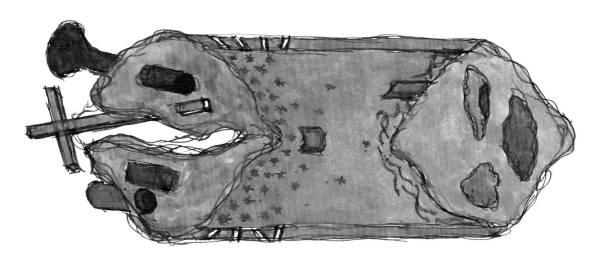

PRAGUE CHAPEL

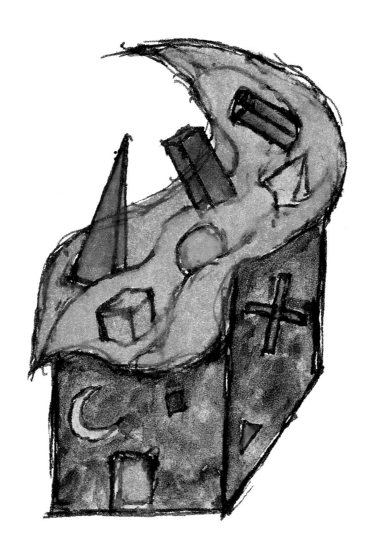

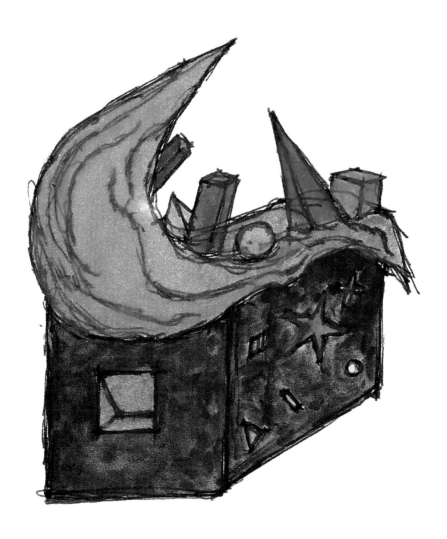

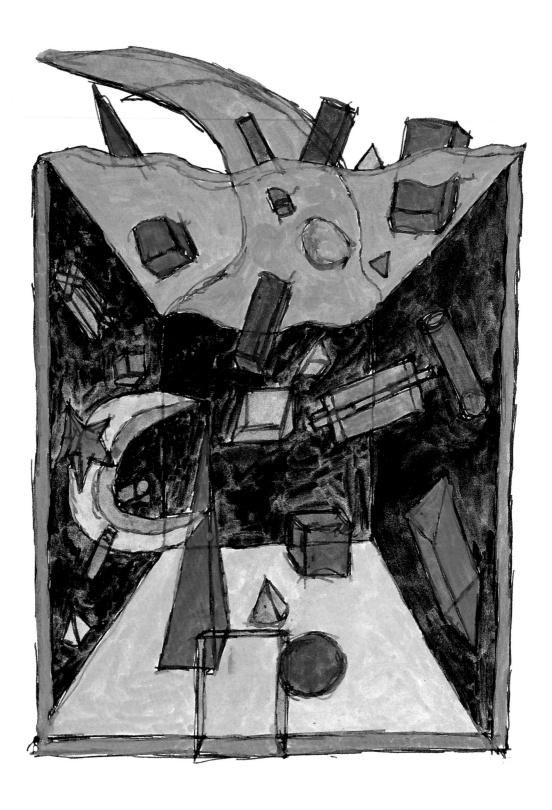

EAST

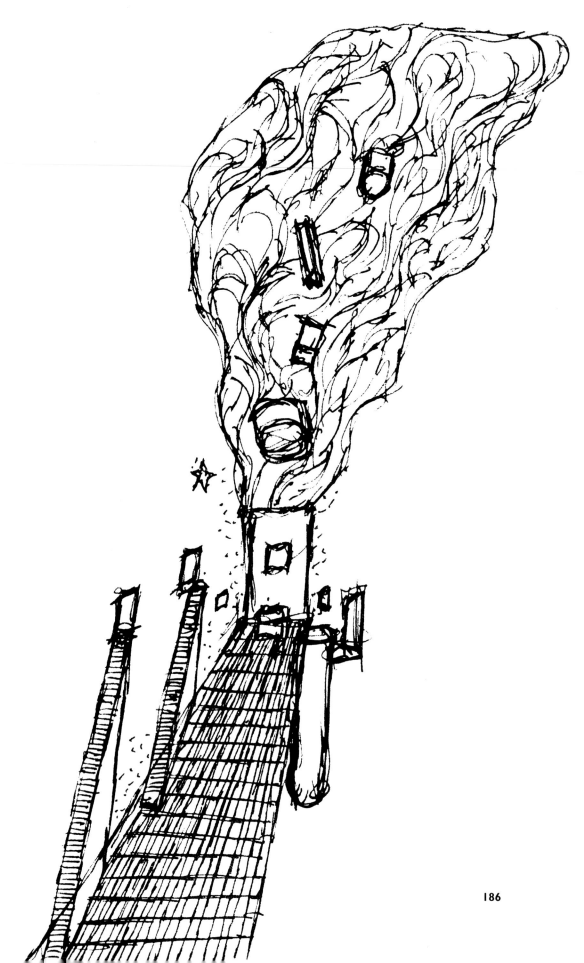

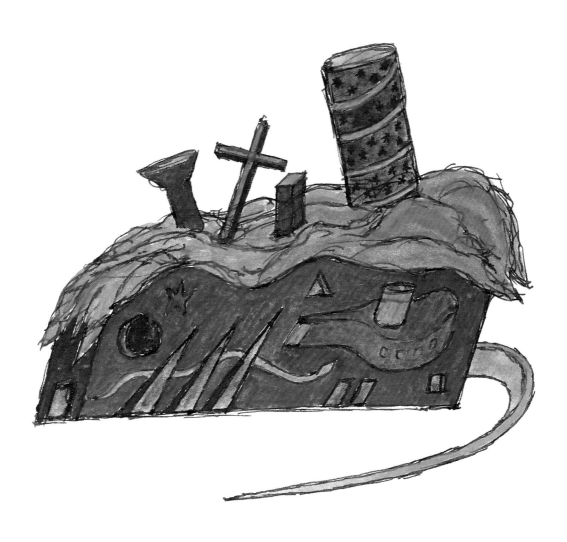

THE SEAMAN'S CHURCH

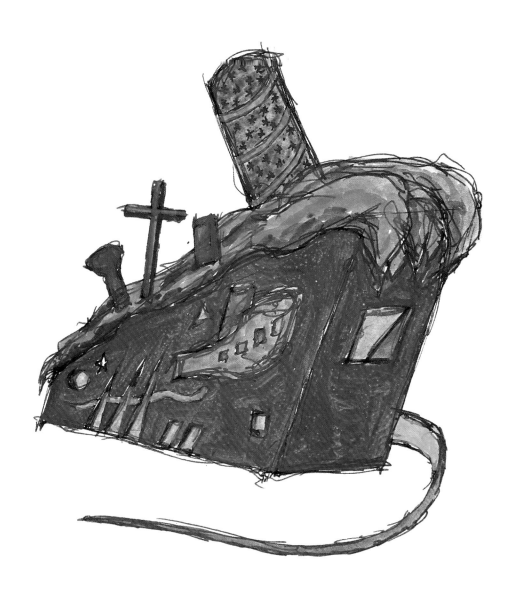

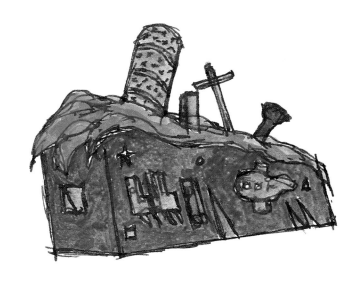

UNDERSEA

THE SOLID WAVE

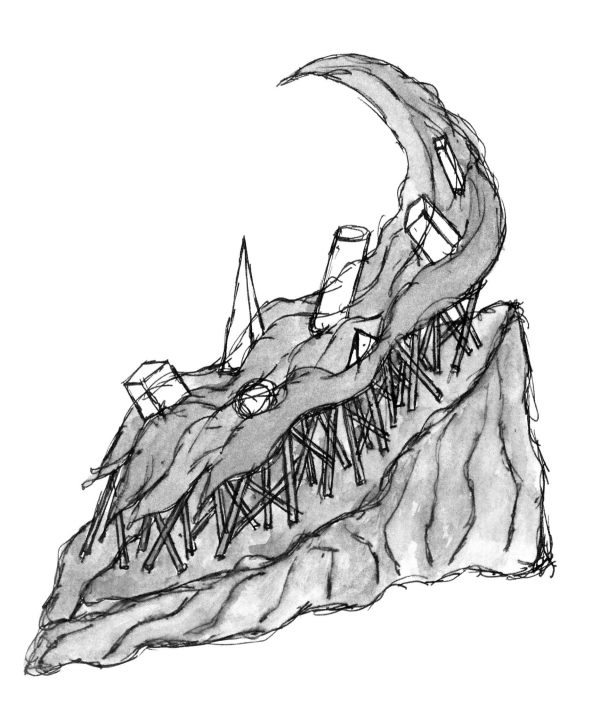

SOUND VOLUME HOUSE

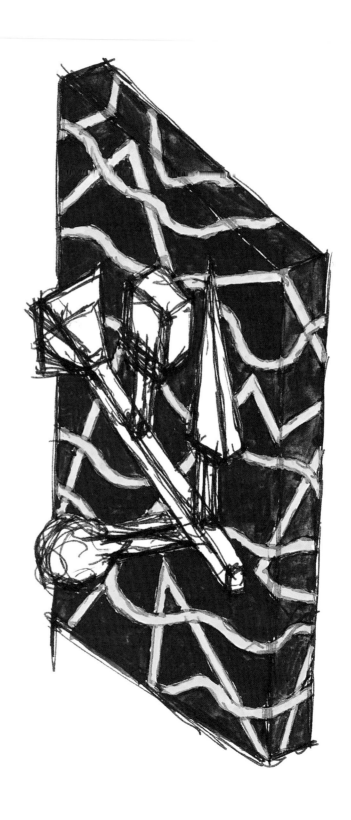

Volume in Music.
Volume in Space.

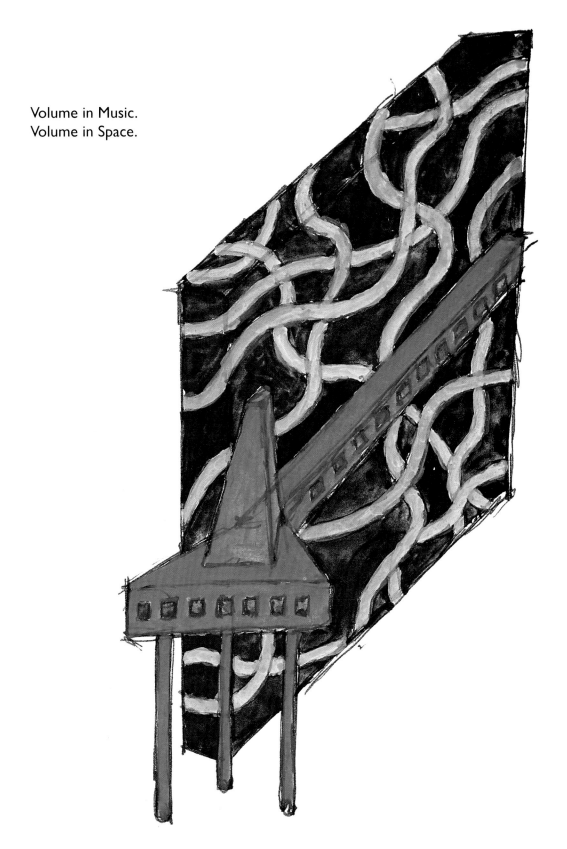

THE SUSPENDED PUNCTURED ROOF

From September to December 1992, I went through an intense period of pure study. I studied and studied; I revisited my love of cubism. I also looked deeply into the sheer joy of Matisse's work and looked upon the still lifes of Cezanne with a deliciousness. I had the time to listen without interruption to blocks of music. This was a special moment for feasts of the eyes and ears. Not since my youth had I had such a stretch of time to take things in—in slow time. Study became absorption throughout the body—that is true study. Cells were being made, a sense of relational electricity, current connection.

One day looking through a publisher's catalog I came upon a book titled *Osaka Prints*, covering a series of Japanese Ukiyo-e from 1780 to 1880. I ordered the book, and when I went through the plates, I was struck by the revelation that not only had the Impressionists looked at and known the Japanese prints, but that the Cubists had also taken a deep look at the Osaka prints and had been influenced by what they saw.

And in a shot I knew what I had to do. For a long time I was moving toward the East, and what I wanted to do was to combine—in architecture—the cubism of the West and the Japanese prints of the East. This is what I attempted in the Suspended Punctured Roof drawings.

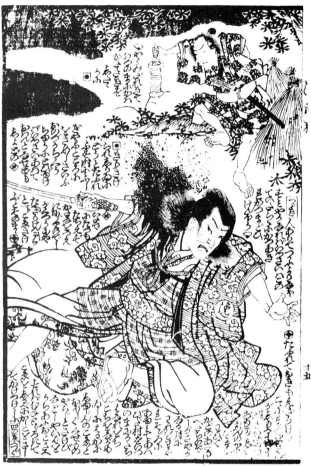

195

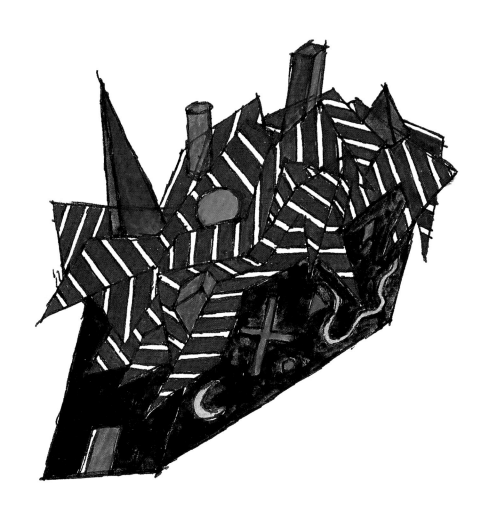

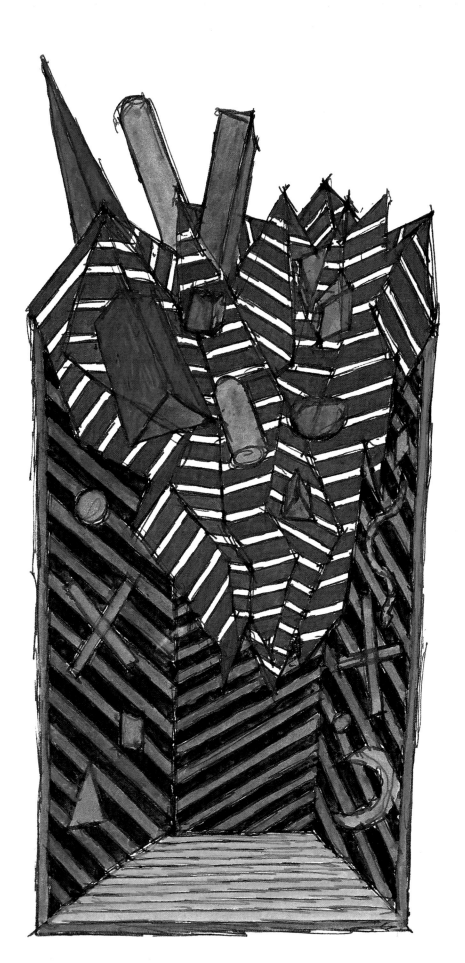

NORTHERN TOWER

TOMB OF THE SUN, MOON, AND STAR

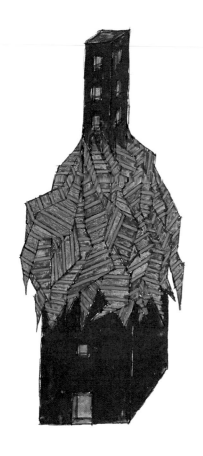

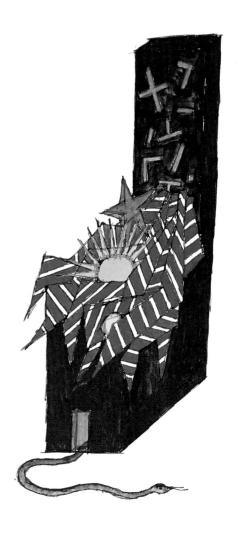

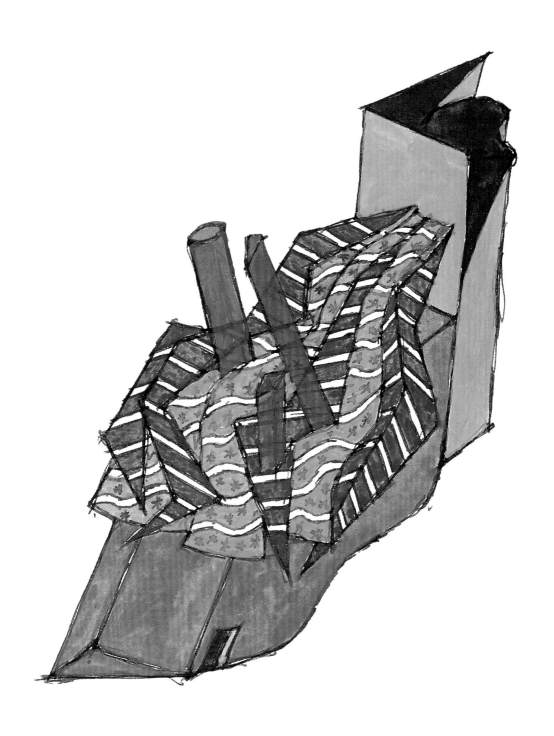

MUNICIPAL BUILDING FOR BAKU

COMMUNITY CENTER

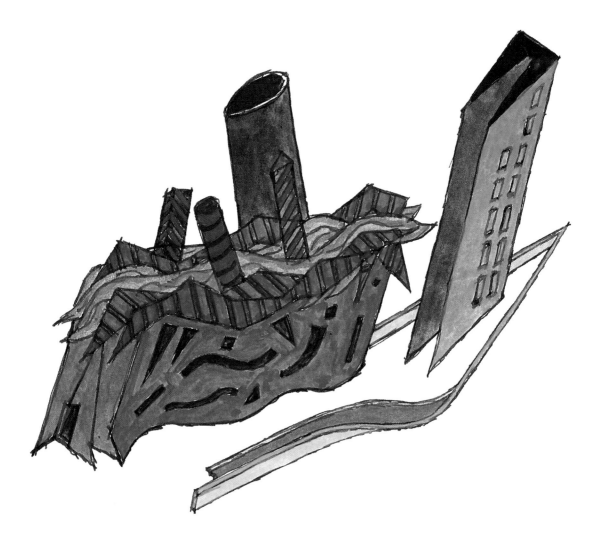

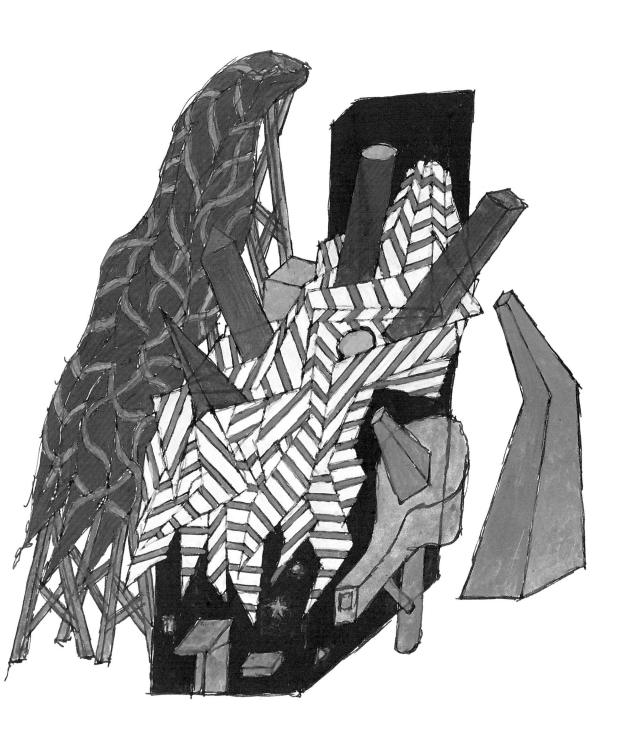

VLADIVOSTOK

HOUSE IN HARBIN

Chinese (Wade-Giles romanization) HA-ERH-PIN, Pinyin HAERBIN, second largest city of Northeast China and capital of Heilungkiang Province *(sheng)*, on the Sungari River. The city owes its origin to the construction of the Chinese Eastern Railway by the Russians at the end of the 19th and beginning of the 20th century. Before 1896 it was a small fishing village. Thereafter it became the construction center for the railway, which by 1904 linked the Trans-Siberian Railroad from a point east of Lake Baikal in Siberia with the Russian port of Vladivostok on the Sea of Japan. Harbin was a base for Russian military operations in Manchuria during the Russo-Japanese War. At the end of that war Harbin temporarily came under joint Chinese-Japanese administration. It became a haven for refugees from Russia after the Revolution of 1917 and for a time had the largest Russian population of any city outside the Soviet Union.

The site of the city is generally level to undulating, except near the river itself, where low bluffs lead down to the flood plain in places. Sandy strips of bank have been used as bathing beaches during the summer months. During the winter, skating and sledding on the river ice are popular sports. Bus services connect the various parts of the city, but automobiles and trucks are comparatively scarce; many work animals, including occasional Bactrian camels, may be seen, especially on the outskirts of the city. Theaters, libraries, hospitals, and schools are well distributed.

—The New Encyclopaedia Britannica Micropaedia

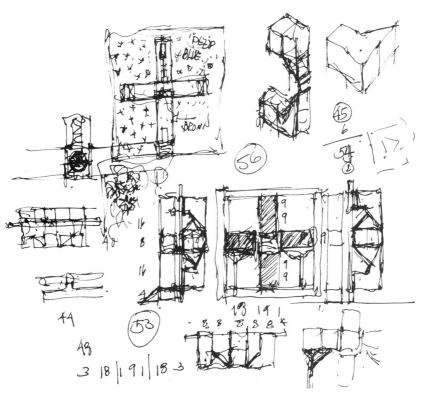

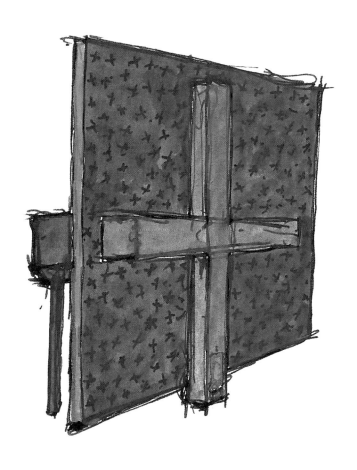

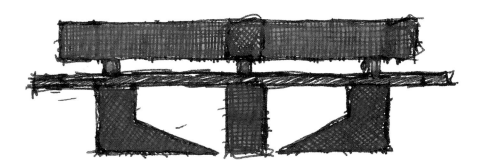

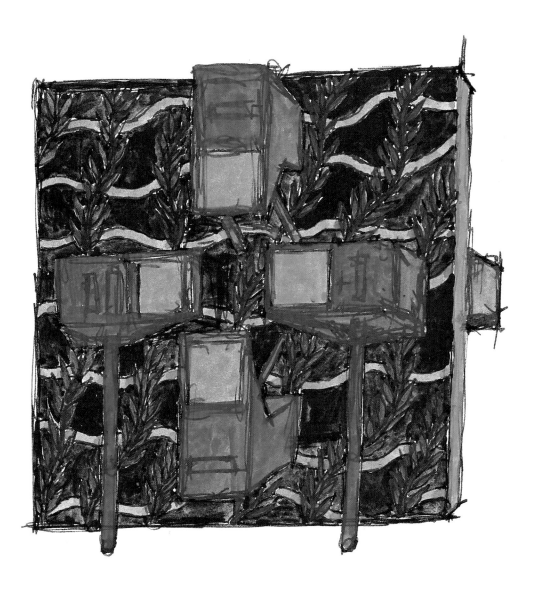

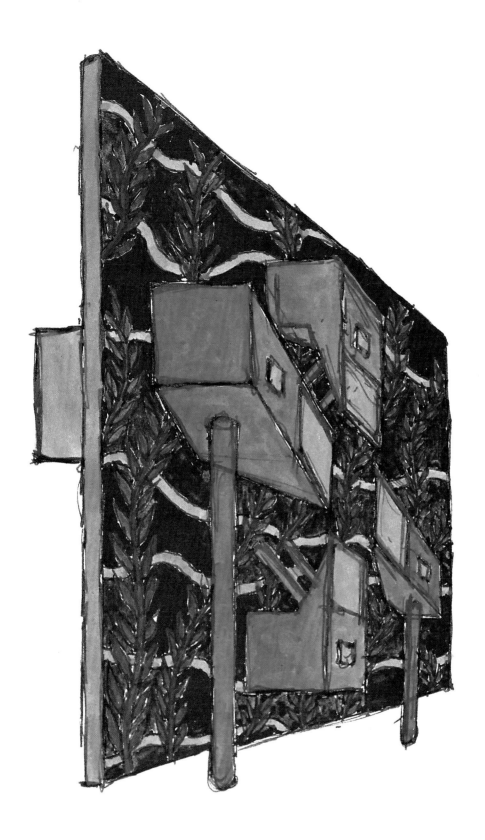

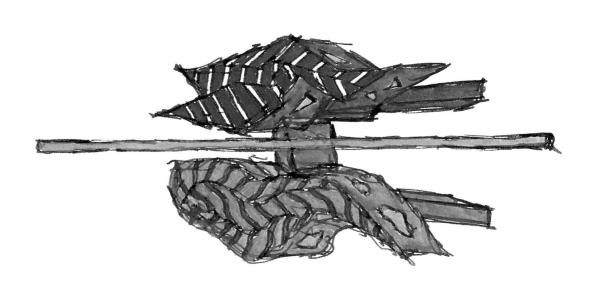

Odysseus longed to be on his way again, and Circe consented to let him go. But he must first visit Tartarus, and there seek out Teiresias the seer, who would prophesy the fate prepared for him in Ithaca, should he ever reach it, and afterwards. "Run before the North Wind," Circe said, "until you come to the Ocean Stream and the Grove of Persephone, remarkable for its black poplars and aged willows. At the point where the rivers Phlegethon and Cocytus flow into the Acheron, dig a trench, and sacrifice a young ram and a black ewe—which I myself will provide—to Hades and Persephone. Let the blood enter the trench, and as you wait for Teiresias to arrive drive off all other ghosts with your sword. Allow him to drink as much as he pleases and then listen carefully to his advice."

—Robert Graves, *The Greek Myths*

ICARUS ARISEN, PERSEPHONE'S DESCENT

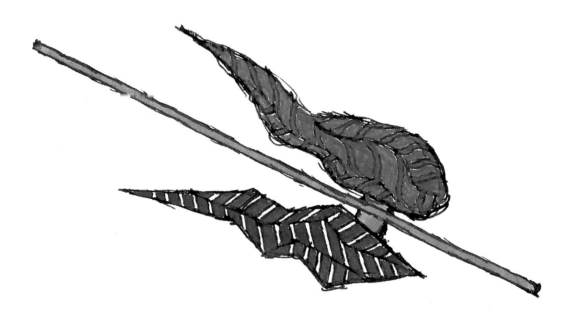

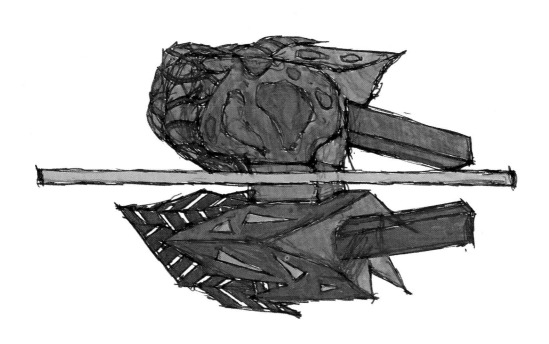

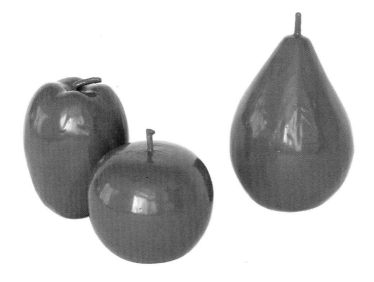

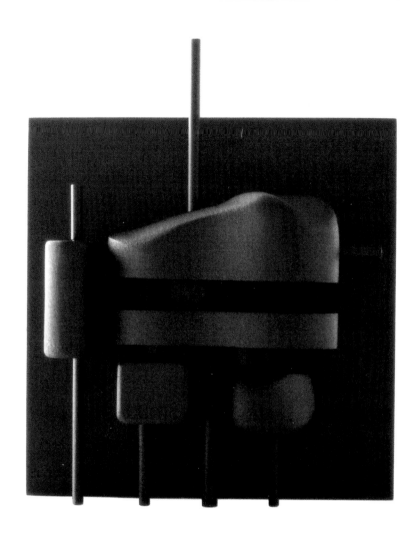

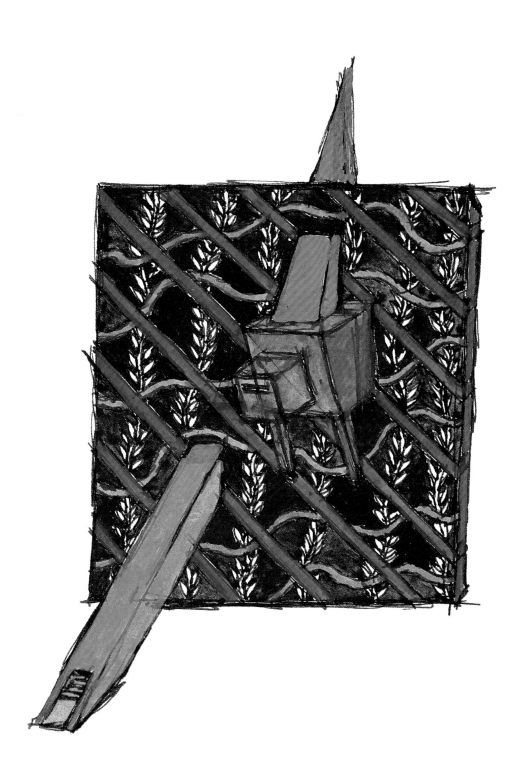

217

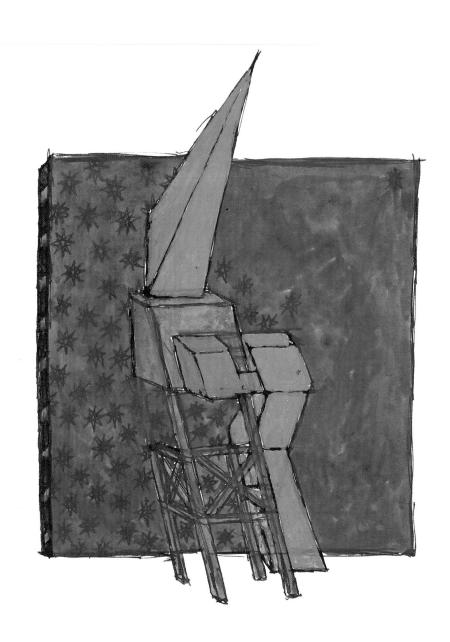

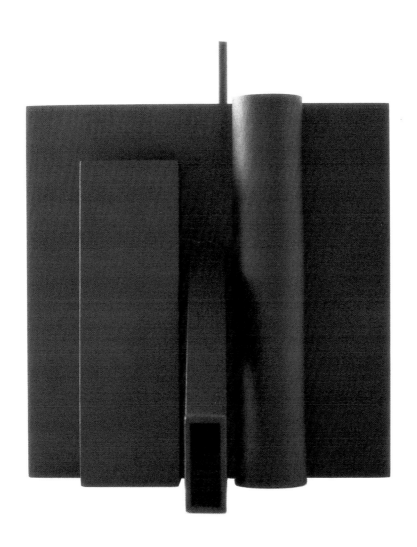

The site moves east, the direction of the river that borders the site on the south; a canal borders the site on the north.

The sequence on the site begins with a high rock/earth mound, on top of which are planted fruit trees. The rock/earth mound contains a cave. The entrance to the cave faces east. A large rock/boulder lies on the plain next to the cave opening. This rock enclosed the entry of the cave; it has been blown outward.

To the east of the cave entry is a flower garden with biomorphic flower beds; curvilinear gravel/dirt paths snake their way through the garden. Exiting the flower garden is a hedge maze, also snakelike. To the north, across the canal, is a dark pine forest.

The hedge maze eases into high curvilinear rough stone walls. Directly to the north are oak trees. The stone walls change into a series of brick walls with an open roof of heavy timber beams. There are no trees to the north of the brick walls. The walls end at the entry to a structure containing utilities, kitchen, bath, toilets, etc., which are lit by funnel-shaped light catchers. This element has a reinforced-concrete slab roof and retaining walls. The curved walls become a series of straight walls, covered in plaster/stucco and vaulted by different-sized reinforced-concrete shells. This structure contains the remaining elements of the house: bedrooms, etc. A copper beech tree is to the north. The east end of this part of the house faces three east-west slots that contain ramps descending beneath the earth, leading to underground burial vaults. Above the vaults, on the earth's surface, lies a series of flat black granite slabs; to the east of the slabs are marble death houses. Across the canal from the built elements are dark cypress trees. The death houses face God's house. On the roof are the sun, the moon, earth, a cone of fire, and metal lightning. Below the site is the warehouse of offerings.

The river/stream continues eastward and meets a dam; a waterfall drops from the dam to the horizontal rapids, which are filled with large rocks and stones. The northern canal enters a series of locks that move down and to the east. To the north of the locks are weeping willows.

THE WOODEN MEDUSA

I WAKE UP WITH A THOUGHT. . . . I WILL MAKE AN ARCHITECTURE OUT OF INK DROPS (BLOTCHES) ON FOLDED PAPER . . . ABSORBENT, NON-ABSORBENT. . . . THE RESULTING SHAPES OF THE INK WILL BE PLANS, SECTIONS, ELEVATIONS, AND DETAILS.

HARD-EDGED FOLDS CAN BE MADE ON PAPERS OF DIFFERENT SIZES AND TEXTURES AND CAN HAVE AS MANY FOLDS AS ONE WANTS. THE INK DROPS CAN BE OF A VARIETY OF SIZES AND COLORS, MIXED OR BLED, INSERTED ALONG THE FOLDS OR CONTOURED TO EACH OTHER.

THE DIFFERENT FOLDS CAN BE BENT INTO CURVES BEFORE THE INK IS APPLIED OR WHILE IT DRIES. THE FOLDS CAN BE TANGEN-TIALLY TOUCHING, OVERLAPPING OR LAYERED.

THE POSSIBILITIES FOR DETAILS ARE IMMENSE IN SCOPE.

THIS IDEA/THOUGHT TAKES ON A NUMBER OF ISSUES: FREUDIAN AND JUNGIAN ANALYSIS AND THE RORSCHACH TEST; DELEUZE'S THEORY OF BAROQUE ARCHITECTURE; THE CONTROLS ON CHAOS THEORY, ALONG WITH THE UNIVERSE EXPANDING INTO BLACK HOLES, BLACK LIGHT, AND THE LUMINOSITY OF NIGHT; BLOTTER THEORY; AND LEIBNIZ'S MONAD THEORY.

THE QUANTITY OF INK CAN BE REGULATED WITH DROPPERS. THE FOLDS CAN ATTAIN THE COMPLEXITY OF JAPANESE ORIGAMI AND THE RICHNESS OF THE OSAKA PRINTS.

THE DENSITY AND THICKNESS OF THE ARCHITECTURAL MATERIAL CAN BE INFERRED FROM THE THICKNESS, DEPTH, TRANSLUCENCY, TRANSPARENCY OF THE INK ABSORBED IN THE PAPER.

THE INK SHAPES CAN BE MICROSCOPICALLY CUT OUT PERMIT-TING THE SPACES THEN TO BE BENT OR FOLDED TOGETHER.

WHEN THE ARCHITECTURE IS COMPLETED THE INNER SURFACES —CEILINGS, WALLS, FLOORS—CAN BE SURFACED IN A MULTITUDE OF RORSCHACHIAN SHAPES: BLACK SHAPES ON WHITE SURFACES IN SMALL TILE AS IN MATISSE'S CHAPEL OR, PERHAPS, WITH MORE DIFFICULTY AS A FRESCO TECHNIQUE, OR AS A PHOTOGRAPHIC PROCESS PRINTING ON A SPECIAL SURFACE.

ONE CAN IMAGINE THE EXTERIOR OF THE ARCHITECTURAL SUR-FACES FOLDED AND BENT, WITH OPENINGS MADE FROM THE SPACE LEFT OVER FROM THE INTERSECTIONS OF THE INK SHAPES/FORMS. THE ARCHITECTURE WOULD HAVE A BLACK EXTERIOR.

SMALLER ELEMENTS (CHAIRS, TABLES, ETC.) WITHIN THE BUILD-ING CAN BE CONCEIVED AND FABRICATED THROUGH THE SAME PROCESS.

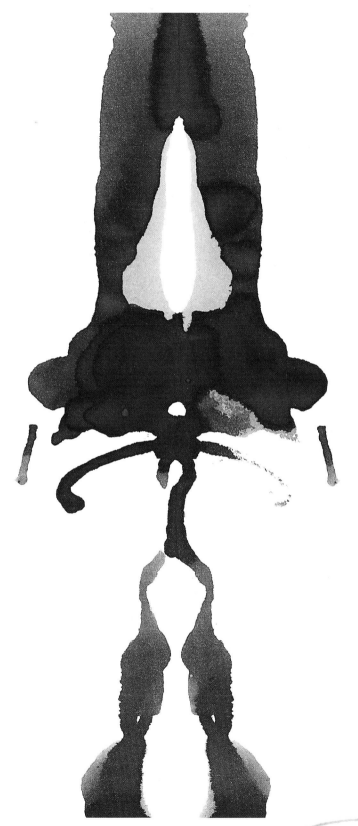

ACKNOWLEDGMENTS

Pieter Sanders

Rudolph Brouwers

Lily Hermans

Simon Franke

Herman van Dongen and Company

The Nederlands Architectuur Instituut

Gianfranco Monacelli

Monica Cavazzini

Julia Joern

Andrea Monfried

Steve Sears

Paola Gribaudo

James Lotti

Richard Henderson

Monica Shapiro

Heather Becker

Steven Hillyer

Jennifer Lee

Kenneth Gilkes

Osvaldo Torres, Image One

The Board of Trustees of The Cooper Union

John Jay Iselin

Edward Colker

Robert Hawks

Text pages 78–79, excerpted from a conversation with Professor Christopher Janney as part of his Advanced Concepts Seminar "Sound As a Visual Medium."

Photo page 90, courtesy Hélène Binet.

Page 136, Paolo Uccello, *Niccolò Mauruzi da Tolentino at the Battle of San Romano.* Reproduced by courtesy of the Trustees, The National Gallery, London.

Pages 136–37, Paolo Uccello, *Le Bataille de San Romano.* Reproduced by courtesy of Musée du Louvre.

Pages 136–37, painted scroll of Mongolian Invasion, 1293. Imperial Household Collection.

Page 137, Paolo Uccello, *Battaglia di San Romano,* 1432–56. Reproduced by courtesy of Galleria degli Uffizi-Firenze, transparency courtesy of Arte e Immagini, Firenze.